IMAGES
of America

BIG BEAR

This book is dedicated to the memory of Thomas H. Core (1915–2006). Synonymous with Big Bear history, Tom enjoyed a love of Bear Valley going back to 1923. He was president of the local historical society, author of numerous books on Big Bear, and writer for more than a decade of historical columns for the local *Grizzly* newspaper. He recently had a road in Big Bear named in his honor. Both authors knew Tom for many years as a true friend and someone always willing to share his extensive knowledge and collection of Bear Valley images. It would have been only fitting for Tom to have written this book, but his failing health made that impossible. We only hope to do justice to his memory with this glimpse into the wonderful history of the valley that Tom loved so much.

ON THE COVER: Early motorists travel the road along Big Bear Lake.

IMAGES
of America

BIG BEAR

Stanley E. Bellamy and Russell L. Keller

ARCADIA

Published by Arcadia Publishing
Charleston SC, Chicago IL, Portsmouth NH, San Francisco CA

Printed in the United States of America

Library of Congress Catalog Card Number: 2005937818

For all general information contact Arcadia Publishing at:
Telephone 843-853-2070
Fax 843-853-0044
E-mail sales@arcadiapublishing.com
For customer service and orders:
Toll-Free 1-888-313-2665

Visit us on the Internet at www.arcadiapublishing.com

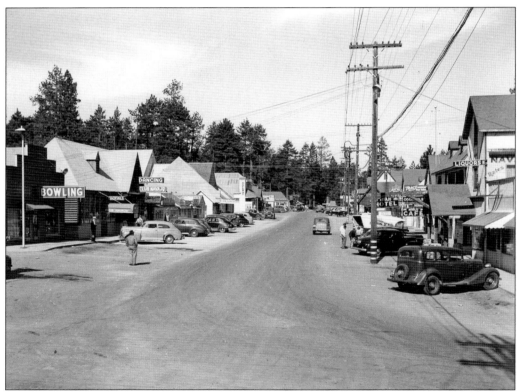

This 1940s postcard shows the business district of Big Bear Lake, a city located high in the San Bernardino Mountains on the shores of its namesake. The message on the reverse states, "Hi Mom, wish you were here. [You] don't know what you're missing." To find out "what you're missing," read on.

CONTENTS

ACKNOWLEDGMENTS

It has been my pleasure to do this book. I was flattered and appreciative when Stan asked me to participate with him, and I thank my coauthor for this opportunity. I owe huge thanks to Tom Core, for the research and documentation that he has allowed us to use here and for the unlimited use of images that he has accumulated over many years. I also thank John W. Robinson for the wonderful work he has done in his book *The San Bernardinos*, which I have used in researching Bear Valley history. Special thanks go to W. Lee Cozad, whose help made the chapter on movies possible. And, lastly, I wish to thank Roger Hatheway for encouraging me to write about the San Bernardino Mountains and for being a good friend.

— Russ Keller

The publishers approached Tom Core, the foremost historian of the Big Bear area, to prepare a photograph history of the Big Bear Valley and surrounding areas. But due to other obligations and failing health, Tom turned down the offer. The Rim of the World Historical Society was then asked, and the president turned to me. But I resisted due to a lack of resources. The society, however, persisted, and I agreed only if I could have another member coauthor the work with me. Russ Keller, who has a vast archive of photographs and writes a weekly historical column for the local newspaper, agreed to work with me. With his assistance and a push from Tom Core, who gave us his blessing and about 200 photographs, we got started. Russ and I have spent many hours selecting photographs, some that have never been published, and writing captions. Without Russ's assistance, I would never have accepted the responsibility. My thanks go to Tom and Russ, as well as to the Big Bear Museum, for its encouragement and cooperation.

— Stan Bellamy

Unless otherwise noted, all images used in this publication are from the collections of the authors or Tom Core.

INTRODUCTION

If Benjamin Wilson had been accompanied by a naturalist in 1845 when he found his way into the Sierra Nevadas, as he called the San Bernardino Mountains, there would perhaps be a record of not only a valley "alive with bears," but also a record of the other animals existing there. Many, like the California grizzly bear that he and his men saw, have become extinct. The last grizzly is said to have been killed in the San Bernardinos in Swarthout Canyon during the 1890s.

Wilson, along with his 80 armed men, had set out to find the bandit Joaquin, but killed 11 bears on their first trek through the valley—and another 11 on their return trip. It is doubtful that the first people into this pristine area would see anything familiar today. The valley has attracted human beings for perhaps thousands of years, at first as an area where Native Americans came to gather acorns for meal and plants that would aid in their survival in the deserts, as well as the meat and hides of various animals.

The valley now attracts a different type of human being, one which swells the population by thousands on weekends and during special events. People come now for recreation, to partake of the area's pleasures and beauty, to escape the crush of the city and freeways, and to breathe clear, smog-free, and naturally pine-scented air. They come to challenge the ski slopes, fish, swim, sail, hike, four-wheel, bike, and, in many cases, retire.

There are "high-gear roads," gas stations, automobile repair shops, and a used-car dealer. The area has supermarkets, fast-food chains, restaurants with superb menus and service, banks, drugstores, convenience stores open all night, and a tattoo parlor. There are churches, schools, libraries, newspapers, a local television and radio station, civic organizations, a zoo, golf course, historical society, museum, and water slide. There are motels, hotels, a movie theater, gift shops, a couple of arcades, an interpretive center for the Unites States Forest Service, an airfield, fire and sheriff's departments, parks, a hospital, and Big Bear City. There are builders, real estate offices, mobile home parks, RV parks, campgrounds, and a military surplus store. If there is something a modern day human being wants or needs, Big Bear Valley can provide it.

However, with this invasion of people, there has come a sacrifice. A dam with a lake behind it covers a good portion of the valley. No longer do animals like the California grizzly, bighorn sheep, or the pronghorn antelope roam freely with deer that once numbered in the tens of thousands.

Gold brought prospectors to the valley. In 1852, the Mormons knew the precious metal was in the mountains but hesitated to seek it out. Benjamin Wilson and his troop seemed to be unaware of its existence; neither he nor any of his men returned to investigate the possibilities. Sydney Waite and Joe Colwell heard rumors of gold and went to see for themselves. William Holcomb along with Jack Martin found it, and when Martin returned to civilization for supplies, he could not keep his secret. And the news spread.

"What a clover field is to a steer, the sky to the lark, a mud-hole to a hog, such are new diggings to a miner," wrote William J. Trimble in his book *The Mining Advance into the Inland Empire* (1904). By the summer of 1860, nearly 2,000 gold miners flooded the valleys and hillsides; some were able

to extract $5 worth of gold in a day just from the surface. Others, with money and time to invest in more sophisticated equipment than a simple gold pan, extracted as much as $50 a day.

So roads were built, and a city grew up with a butcher shop, restaurant, hotel, and saloon. Many miners were from the gold fields near Sacramento and, failing to find riches there, came to Holcomb Valley. Some brought their families. A teacher was hired and a school organized. But many were not family men. Some were murderers and thieves, who would kill their partners for the other man's shares. Soon gold was so scarce that it was not worth processing, by hand or machine. People left, mines closed, and towns fell into ruins. The mining towns of Doble and Belleville were left to the elements, and almost nothing remains for the historian to see.

A different kind of "golden" commerce was found in Big Bear Valley, but it was not the kind that Waite, Colwell, Holcomb, and Martin had in mind. It was liquid, water. Frank E. Brown, Edward Judson, and Hiram Barton saw a way to feed the ever-growing citrus industries in San Bernardino and Riverside Counties with mountain water. A dam was needed to create a reservoir. The dam was built, and then a higher one to hold back more water, as the men's vision became a reality.

Gold was not only found in the value of water but also in the pockets of tourists, who challenged the trails, which eventually became roads. In time, these visitors discovered their brand of paradise in the mountains—either places to camp or cabins with facilities that enabled them to stay for long periods of time. Entertainment was needed along with food and other supplies. And so, present day Big Bear grew into what it is today—an accumulation of support businesses providing all the amenities.

One

BEGINNINGS

Had Benjamin Wilson not discovered the valley he called Big Bear, no doubt some immigrant or immigrants from the east would have eventually found it. Those who came to the new lands of the West were anxious to see what was on the other side of the mountain and would not have stopped at the base of the San Bernardinos. When the valley was discovered, gold was the first motivating factor to go there, followed by water, then relaxation and recreation. Native Americans lost their lands to the laws of the state and federal governments that divided and legalized land titles that they never recognized. Their fate was determined by officials in Washington, D.C., by executive orders under presidents U. S. Grant and Rutherford B. Hayes in the early 1870s, when they were consigned to reservations. The Serrano, or "mountain people," who frequented the San Bernardinos, did not escape this judgment and were either killed off in battles with ranchers and lumbermen or confined to restricted areas that continue to exist to this day, but without restrictions.

Only a few years after Wilson came to the valley, trails became roads, and word spread about the mountain paradise. From points west along coastal cities, a visitor could reach the valley in a day of hard traveling—today in less than two hours—to find lodging, food, and recreation. Modern visitors do not need to come prepared with their own provisions and accommodations, but in the beginning, it was so. Visitors repaired their own wagons, shod their own horses, and hunted for something to eat. Old William James might not feel at home nowadays, just as we might not want to live the way he did either.

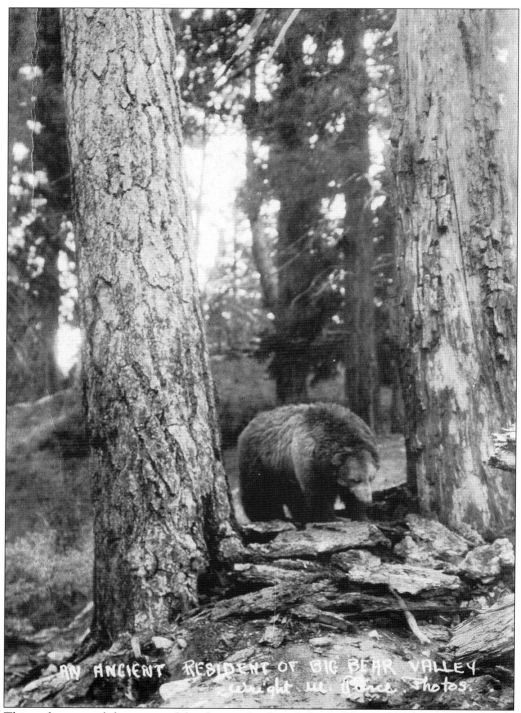

AN ANCIENT RESIDENT OF BIG BEAR VALLEY

This early postcard shows one of the thousands of grizzly bears that once roamed the valley and were the inspiration for the Big Bear name. Benjamin Wilson claimed to have killed 22 bears, but by 1906, no one ever saw another grizzly.

Born in Tennessee on December 1, 1811, Benjamin Davis Wilson came to the Sierra Nevadas in 1841. Commissioned to find the bandit Joaquin in 1845, he tracked him through what he called Bear Valley because it was "alive with bears." He never found Joaquin on this search, but Wilson made his mark on Southern California.

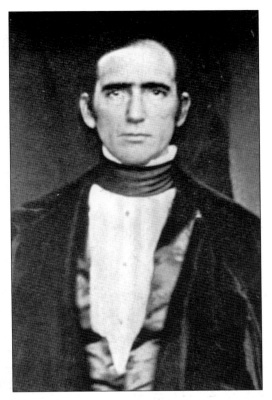

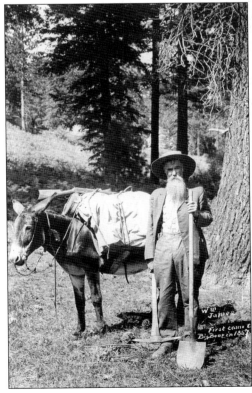

William James, pictured here around 1922, came to the Big Bear Valley in 1857, prepared to strike it rich like so many of the 2,000 others who, on a good day, could make $5. Those with more sophisticated equipment could make $50 a day.

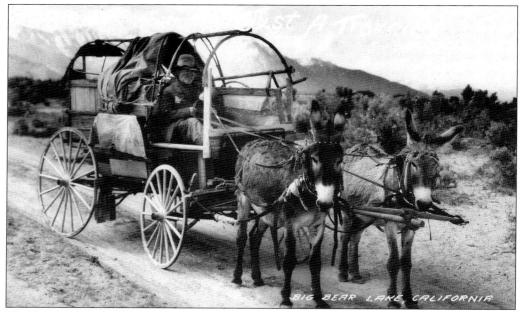

The first road to the area was built in 1860 via Cajon Pass. Without any stores where one could purchase goods, a traveler (like the one pictured here) had to come prepared to exist on what he brought or could find once he arrived. The first automobile did not reach the valley until 1908.

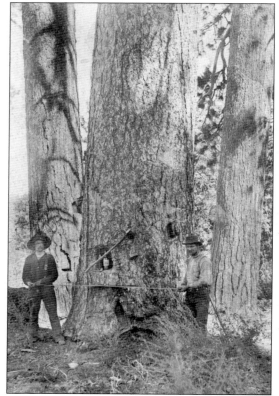

The two men in this image are using a saw that soon became known as a misery whip. It was lubricated by a solution in the bottle pictured in the notch of the tree. Depending upon the strength of the men and the size of the tree, they could fell it in a matter of minutes. In most cases, they were paid $1.25 for a 10-hour day.

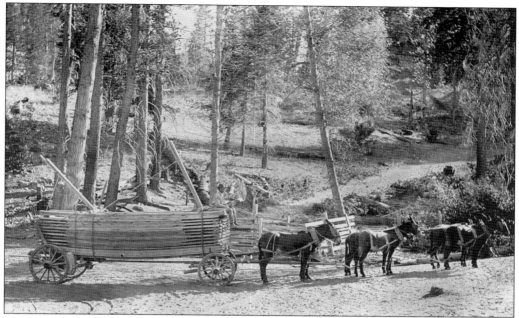

Lumber was usually hauled from the mill to the yards by a four or six span of mules. The teamsters were paid according to the amount of milled lumber they carried. Some exceeded the capacity of their wagons and wound up repairing broken wheels or axles, which resulted in significant loss of income.

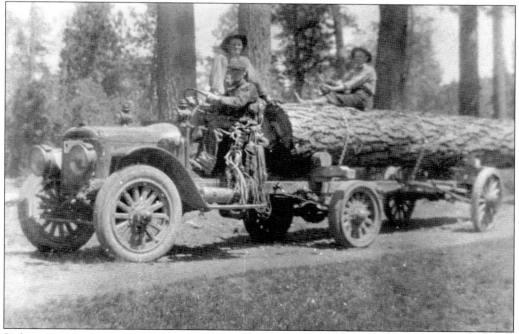

Before 1920, motor power replaced mules, horses, and oxen. Logs are hauled to the new Camp Eureka, built in 1916 by Margaret Betterley, who had purchased the land from Gus Knight. Today's McDonald's Restaurant occupies the land where the camp was located.

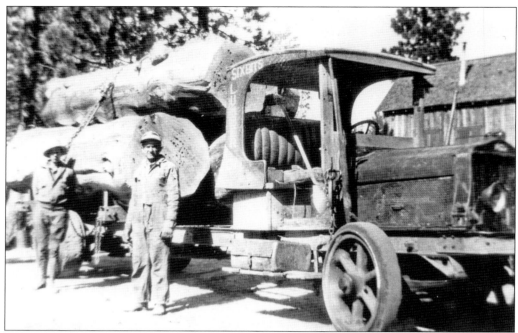

Located today near what has become known as Snow Valley in the Fish Creek area, the Six Bit mill was the result of the hard work and dedication of Tressy Swetkovich, who established it after her husband's death. She drove the trucks, did a man's work when required, and raised three children at this mill.

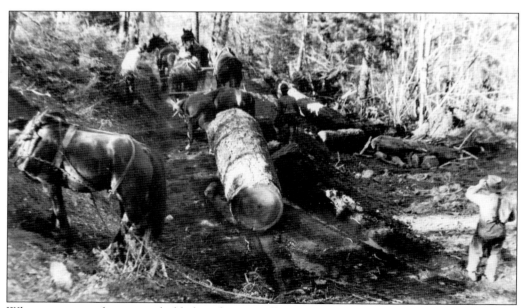

When necessary, logs were skidded to the sawmill. Even as late as the 1920s, ox and horse (or mule) teams were used when the new gasoline-powered trucks could not handle the job. This 1917 photograph was taken near the Snow Summit area.

Two

MINING

Since the first discovery of gold in 1842 in San Feliciano Canyon near Los Angeles, to the gold rush of 1849, the precious metal has had a significant influence on California's history. The San Bernardino Mountains are not left out of this golden past, as the Big Bear area was blessed with this mineral. San Francisco multimillionaire Elias Jackson "Lucky" Baldwin (1828–1909) made his fortune mining Nevada's Comstock Lode. He was one of the more famous players in the mining on Gold Mountain, near Big Bear. But it was William Francis Holcomb's discovery of gold in Caribou Creek in 1860 that set off a gold rush to the valley, which today bears the name Holcomb Valley. With the discovery of gold came all the related stories of corruption, greed, killings, lost mines, booze, and women. Big Bear has had many legendary stories regarding all of these subjects.

In 1864, the nearby city of San Bernardino dubbed Holcomb the "Hell Hole of the Mountains." A notorious resident of Holcomb named Greek George shot three men to death on July 4, 1864, and went unpunished—at least in Holcomb. His comeuppance came years later in Deadwood, Dakota Territory, where he was shot to death by Wild Bill Hickok, a noted sheriff and gunman.

Treasure hunters today still seek the lost mines of Minnelusa and Van Duzen Canyons, with some believing that the mother lode of these mountains remains undiscovered. Two Guns Saloon is a reminder to the visitors of this picturesque and historic location that weapons did some of the major talking in the old days.

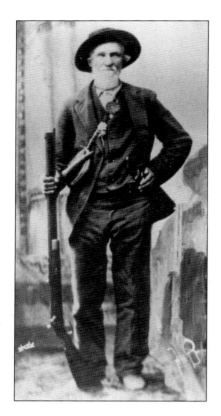

To pioneer miner William Francis "Bill" Holcomb goes the honor of first bringing civilization to the Bear Valley country of the San Bernardino Mountains. His major placer-gold discovery of 1860 brought hundreds of folks into Holcomb Valley, which bears his name. Holcomb, who lived from 1831 to 1912, started the greatest mining rush in the history of the local mountains.

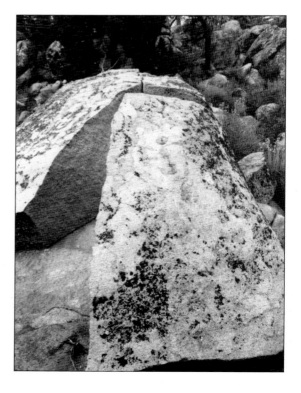

At an early 1860 miners meeting in Holcomb Valley, it was decided that some fixed point should be established from which all claims could be surveyed. Several suggestions were made, but the miners finally drilled a hole into a large split rock in order to insert a brass pin. The rock and the pin at Holcomb's Split Rock are still there today.

This contemporary photograph shows a pigmy cabin, the only remaining structure in Holcomb Valley representing the mining days. The influx of people from Holcomb's gold discovery created the town of Belleville, which lost by only two votes being named the seat of government for San Bernardino County.

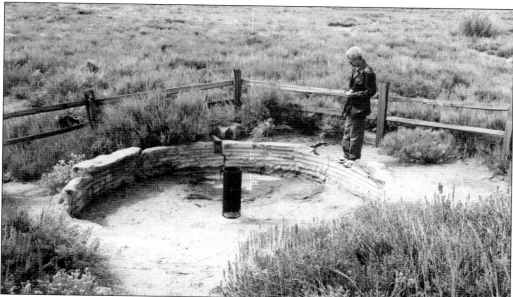

The ruins of an old *arrastre* remain visible in Holcomb Valley today. Used for crushing ore, an arrastre is a rude Spanish-American mill with a vat in which one or more heavy wheels are propelled by a horizontal beam, which turns around a vertical axis. In this photograph, Russ Keller gazes in and wonders about a time lost to history.

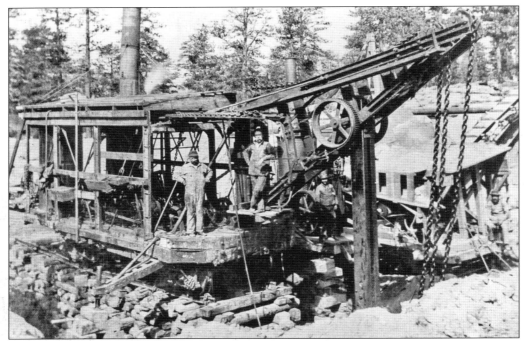

In 1893, this huge standard-gauge railroad steam shovel was hauled in pieces into Holcomb Valley by wagons. Operated by the Valley Gold Company Limited, with headquarters in London, it could hold one cubic yard at a bite and could process 1,000 yards a day. But the gold values were not there, and by 1898, the equipment was abandoned. The huge steam shovel was a Holcomb Valley landmark until it was torched in 1933 and turned into a few dollars worth of scrap.

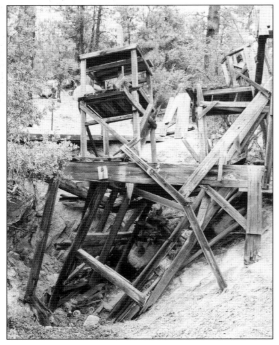

Today a trip to Holcomb Valley will reward the visitor with many views of abandoned mines, like the one seen here. When mining changed from placer to quartz, large shafts were cut into the mountain. Ore was removed to be processed in hopes of extracting gold. This long-since abandoned mine still displays some of its exterior structure and shaft, but its story has been lost to the ages.

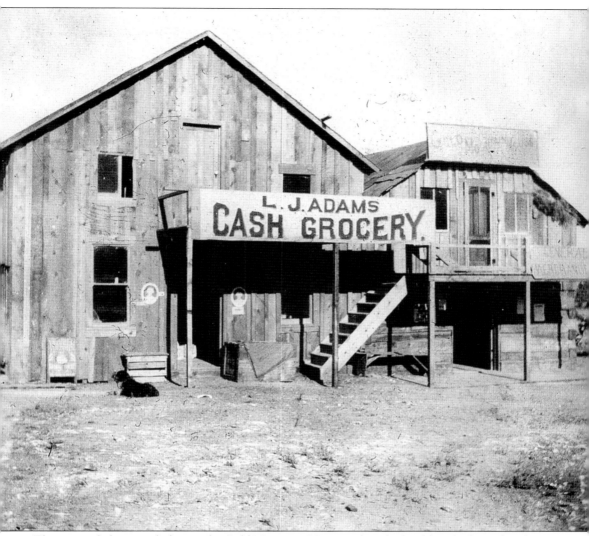

This original photograph depicts the Gold Mountain House, right, which sold general merchandise. One of the first structures at Bairds Town, it was probably built by Gus Knight. The town was named for pioneer developer Samuel Baird in the mid 1870s, after gold was discovered there in 1873. A U.S. post office was established there in February 1875, but, by September, it closed. By October, the town was abandoned. At the time of this photograph, the town of Doble had been established within a mile of the original location of Bairds Town. Doble had been named after "Lucky" Baldwin's son-in-law, Budd Doble. Budd had convinced his father-in-law to let him reopen and manage the mining operation at Gold Mountain in 1893. But by 1895, the operation was abandoned. Budd Doble's stay in Doble was short and uneventful, but his name would later be used when another post office was opened there in 1900, the year before this photograph was probably taken. At that time, L. J. Adams's Cash Grocery was located next door to the Gold Mountain House. Adams was postmaster of Doble from 1902 to 1904. The Doble Post Office operated until August 31, 1906. (Courtesy Lewis Murray.)

This is an early view (c. 1904) of the town of Doble, previously known as Bairds Town and Gold Mountain City. Earlier attempts from the 1890s to again make gold mining profitable resulted in little ore being mined, and the town became abandoned. Today only broken glass and old tin cans remain where the town of Doble once stood. (Courtesy Lewis Murray.)

This original c. 1904 photograph is from an album reflecting a trip taken by Alywin Clarke and three others into the San Bernardino Mountains. At that time, the primary means of transportation was horseback. In the century since their trip, the town of Doble—pictured here—is gone, and travel by horseback is now for fun and recreation. (Courtesy Lewis Murray.)

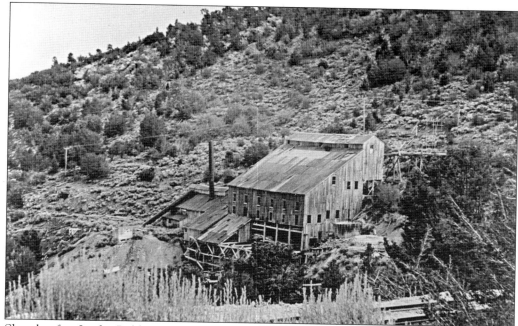

Shortly after Lucky Baldwin purchased 6,000 acres—half of Gold Mountain and the entire eastern end of Bear Valley—he erected a mammoth 40-stamp mill. The mill was completed and in operation by 1875. The boom was short lived, though; the mill was shut down later that same year and was destroyed by fire in 1878. Mining activity continued on Gold Mountain well into the 20th century, but the anticipated new booms never materialized. This image of the second Gold Mountain stamp mill was taken around 1932. Baldwin's original mill, in its day, was the largest in Southern California.

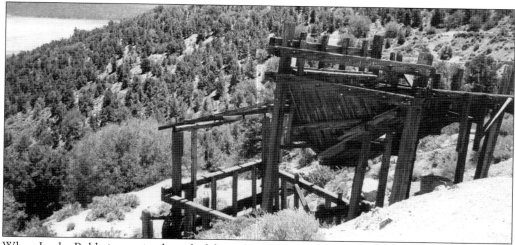

When Lucky Baldwin received word of the rich Gold Mountain strike, he decided to travel to the Big Bear area and see for himself the mountain of gold. It was on this trip to the San Bernardino Mountains that he traveled through the San Gabriel Valley, where he later bought the Rancho Santa Anita and made his Southern California home. He purchased the Gold Mountain properties, developed the mines, and built a 40-stamp mill. Visible in this image are the rotting timbers of the old relic. Most of the equipment was removed in 1951.

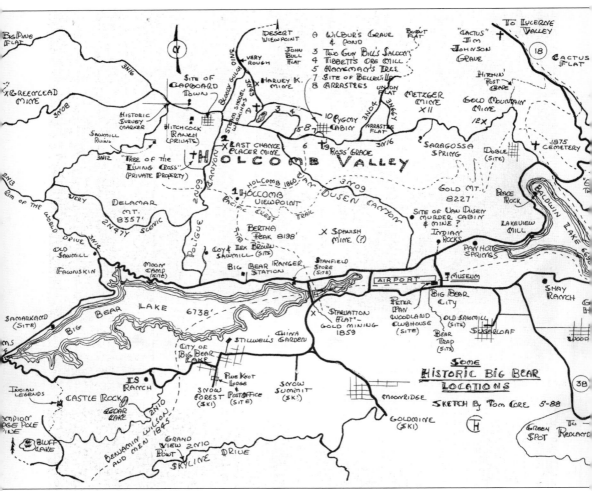

Here is a Big Bear Valley Historical Society map sketched by Tom Core in 1988. Featured are many historic locations that can still be found in Holcomb Valley, Big Bear Lake, and Big Bear City.

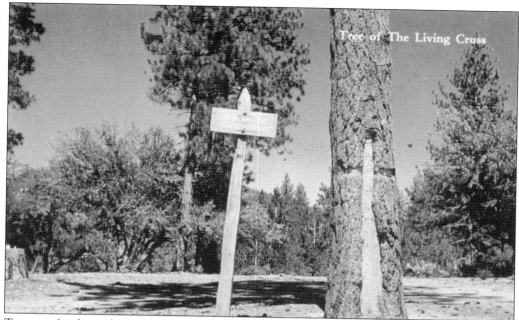

Two men fought to the death to settle a claim dispute in the early, lawless days of Holcomb Valley. They had come from opposite sides of the Earth—one from China and the other from Greece—to find gold. They found only death. The citizens of Holcomb buried the two men beneath the pine tree where they had died. To mark the graves, they carved a cross into the tree. The original "Tree of the Living Cross" fell during a winter storm in the 1950s, but the Boy Scouts (who now own the property) have appropriately marked this adjacent pine.

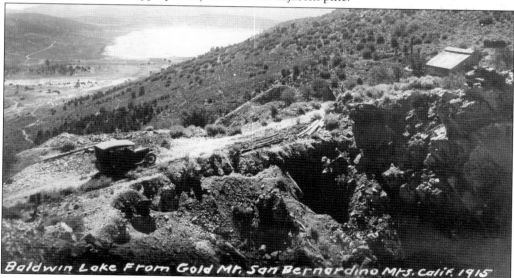

In 1915, an old car ascends the road to the Gold Mountain Mine stamp mill on Gold Mountain. In 1883, Dr. Cyrus Gradison Baldwin visited the area and saw the lake as a potential site for a major hydroelectric installation. He drew a map, naming the lake Baldwin's Lake. Whether it was named for him or for "Lucky" Baldwin, who operated mines and owned property in the area, remains a mystery.

23

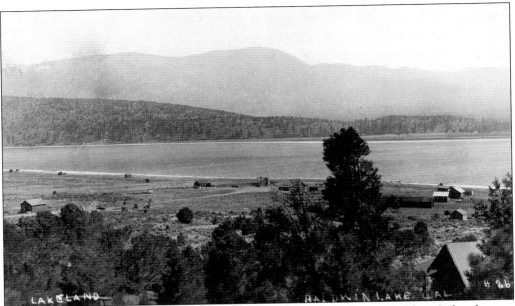

This c. 1920 photograph shows Lakeland. Located on the north shore of Baldwin Lake, the area was developed as the Lakeland Tract and Lakeland Pavilion. There was a dance floor and outdoor fireplace with other buildings, some of which lasted into the 1990s. Now all that remains are the concrete floor and parts of the fireplace.

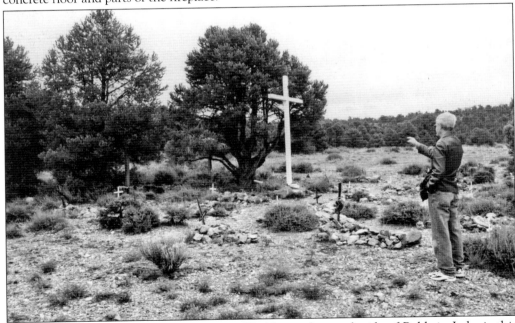

The only remaining marker of the town of Doble on the north side of Baldwin Lake is this cemetery, which contains many unmarked burial sites. This lonely and forlorn spot has suffered from time and vandalism, and it only survives due to the care given by the Big Bear Historical Society. The large, white cross has been maintained by Tom Core and his son Ronald. Here author Russ Keller pays his respects in 2005.

Three

ROADS

Those who visited Big Bear Valley and found a need to return—to bring mining equipment, families, tools for building, or ideas for the recreational future—all saw the need for reliable roadbeds that could be traversed all year.

Those who have maintained the trails that became roads found it a difficult task to keep them open year-round because of the heavy snows and other elements. Today those who need to reach the mountain communities, or just to get off the mountain to their jobs in the valley, understand that there are very few days when it is impossible because of road closures. However, closures do occur. Snow, landslides, washouts, earthquakes, accidents, fires, and resurfacing and repairing keep the county and CALTRANS busy. Sometimes the challenge is too great, as during the winter of 1969, when every road into or out of the mountains was closed for up to a week because nature proved more powerful than any workforce. But some mountain people could not to be stopped. One fireman needed to report to his firehouse in the valley and rode a bicycle down the perilous highway to reach his destination. During the fires of 2003, some reached their mountain homes by walking the entire distance.

New "roads" have opened. At least two airfields exist, and helicopters can land almost anywhere they are needed to assist in fire suppression or medical rescue. While it used to take most of the day to reach the mountain tops from the bottom of the hill, they can now be reached in a few minutes. William Holcomb would be impressed.

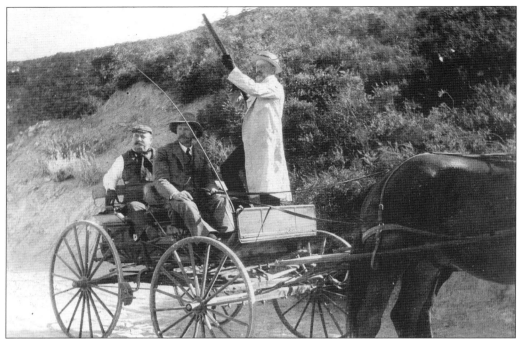

Here is another photograph depicting an early trip into the San Bernardino Mountains. The caption "Mountain Nimrod" was placed in the photo album by the gentleman at the rear of the buckboard. Although "mighty warrior" is an exaggeration for early travel in this desolate area, there was still a threat of mountain lions. By the early 1900s, the bear population had been eradicated. (Courtesy Lewis Murray.)

The midpoint of Waterman Canyon was built on to house workers for the new Rim of the World Highway, which began construction in January 1912 and finished two years later. This location is near the site of a devastating flood that killed 14 people on Christmas Day in 2003 and would have claimed more lives had it not been for the quick action of San Bernardino County sheriff Tracy Klinkhart and his department.

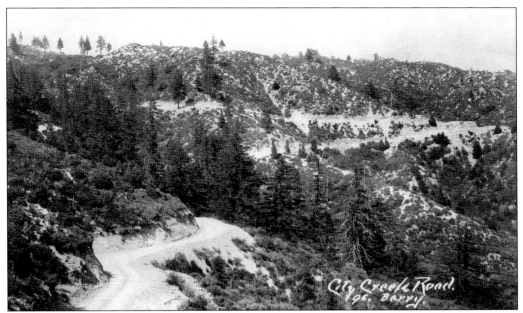

C. D. Danaher was the owner of the Highland Lumber Company, whose sawmill was near the Catholic church off Highway 330 in Running Springs. As early as 1891, he began to build a road with a 10 percent grade up City Creek for a rail line to move lumber to his Highland mill. He soon gave up on the Danaher Grade when it presented too much of a challenge.

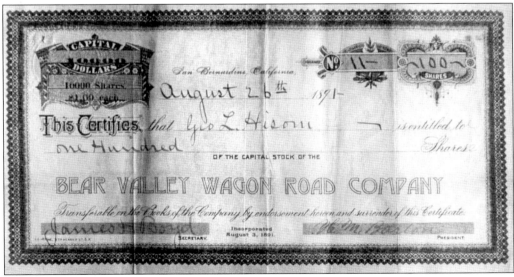

Most roads into the mountains were, at one time, toll roads. Funds from these roads went to pay the investors. With the completion of the Bear Valley Wagon Road from Hunsaker Flats (Running Springs) in May 1892, stagecoaches began scheduled runs into the valley three times a week.

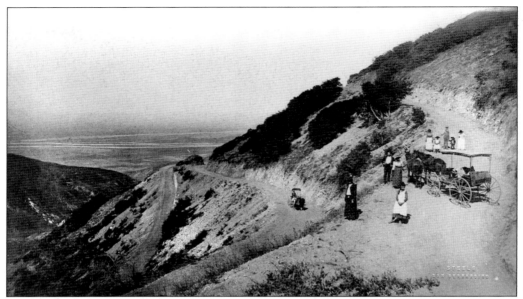

This is Panorama Point in 1898, looking west. The Arrowhead Reservoir Company built the road to bring cement up to the construction site of the Little Bear Dam, which was later to become Lake Arrowhead. This road basically followed the existing route of today's Highway 18. From this point, it took an uphill grade to Oak Flats, Mormon Springs, and Skyland, past the Squirrel Inn, and ended at the construction site. Only a trail existed from there to Hunsaker Flats (Running Springs).

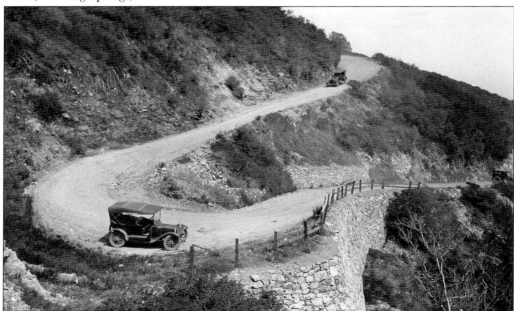

One of the most popular photo opportunities on the old switchback road was at this point. This road continued to be traveled until the winter of 1968–1969, when the upper section washed away. The location of this photograph is still visible about a quarter mile north of the present-day Highway 18, east of Panorama Point.

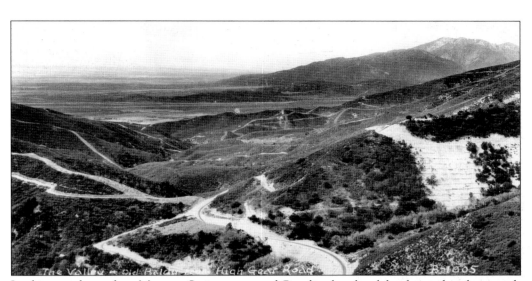

Looking southwest from Mormon Springs, renamed Crestline by a local developer, this photograph shows the road cuts that marked the landscape in the 1930s. Two access roads are visible: the present grade and, at a higher level, the switchback road built by the Arrowhead Reservoir Company some 30 years earlier. On the flat area of this road, known as Oak Flats, was a store and family residence.

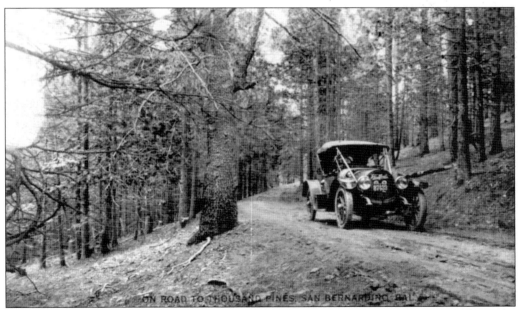

Perry Green, brother of Max Green, who organized the Mountain Auto Line in 1912, drove the first automobile up the high-speed road in high gear in 1914, opening up a new era in travel in the San Bernardino Mountains. This photograph was taken near Thousand Pines, and the Greens might be shocked to see at how high a speed many travelers traverse these roads today.

SPHINX ROCK (FOG)

BIG BEAR LAKE

CLARK'S GRADE

SAN BERNARDINO. CAL.
426 D Street
LOS ANGELES. CAL.
623 South Spring Street
REDLANDS. CAL.
Triangle

*"101 Miles on the Rim
of the World"*

Mountain Auto Line

San Bernardino, Cal.
December Four,
Nineteen Nineteen.

Forest Home Outing Co.,
Redlands, Cal.

Gentlemen:-

 We have had no reply to a recent letter in
which we requested finial settlement of your account.
This matter can not be permitted to remain longer unsettled
and we ask that you hand us your check by return of mail
in the sum of $203.93.

Yours truly,

Max Green

check in few days

LOS ANGELES BRANCH OFFICES

B. H. DYAS CO., 321 West Seventh Street. TUFTS-LYON CO., 428 South Spring Street. TRAVEL BUREAU, Broadway Department Store.
WM. H. HOEGEE CO., INC., 138-142 South Main Street. CLINE-CLINE CO., 214 West Third Street, and 350 South Spring Street.

In an effort to provide transportation to the crest resorts in the San Bernardinos, Kirk Phillips started the San Bernardino Automobile Stage Company in 1912, transporting passengers up the Waterman Road to Skyland, Pinecrest, and the Squirrel Inn. Two young brothers, Max and Perry Green, formerly employed by the Arrowhead Reservoir and Power Company, came to work for Phillips. When Phillips died in 1914, Max Green soon became the manager of the reorganized Mountain Auto Line. In 1920, the Mountain Auto Line was sold to the Motor Transit Company, a subsidiary of the Pacific Electric Company, and Max Green left for Los Angeles as general manager. This December 1919 letter requesting payment of an unsettled account is distinctive for its graphics, content, and signature.

30

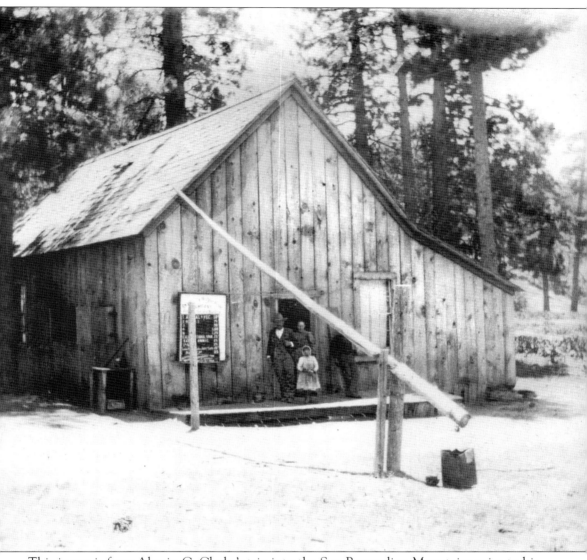

This image is from Alywin C. Clarke's trip into the San Bernardino Mountains prior to his death in May 1904. Gus Knight and John Metcalf's Bear Valley Wagon Road Company opened a toll road in May 1892, from Bear Valley (Big Bear) through Green Valley to meet the Highland Lumber Company's road near Running Springs. Pictured here is the toll gate in Green Valley. This toll road was the first road access to the isolated mountain basin, formerly reached only by horse trails. The Bear Valley Wagon Road Company built this 11-room tollhouse at the east end of the Green Valley meadow. Ben Pitts, a cook and handyman, ran the tollhouse every summer for a decade, furnishing travelers on the overnight stage to Bear Valley with meals and lodging. In 1902, Pitts left to run a hotel in Redlands. In 1903, the Tillitts came to run the tollhouse until the road became public in 1911. With close examination, the rates are revealed as follows: one animal and vehicle, 50¢; two, 75¢; three, 90¢; four, $1; six, $1.25; each additional span, 25¢; saddle animals, 25¢; pack animals, 25¢; loose horses, mules, and cattle, 10¢ each; and sheep, 25¢. Sheep were 25¢ because the cattlemen did not want sheep grazing on cattle lands. (Courtesy Lewis Murray.)

Once travelers made it up onto the mountain, a welcome and pleasant ride across the flats of the Big Bear area was in order. The first car to make it over the 101-mile route across the Rim of the World Highway came up the grade in 1908; it was driven by John A. Heyser of Los Angeles and Opie Warner of San Bernardino in a 20-horsepower, white steamer. Heyser stated in his account that the road coming up the Santa Ana Canyon was an "old horse trail," and that no automobile had ever attempted the ascent. Bets were taken, and the odds were 10 to 1 that the trip could not be completed. Since gas stations were nonexistent, a steam-driven automobile was selected for the arduous task. But even at that, water cost 10¢ a bucket. Heyser and Warner made the trip up the Santa Ana Canyon with much difficulty, then across the Rim, and down Waterman Canyon to win the bet—and their place in the history of the San Bernardino Mountains.

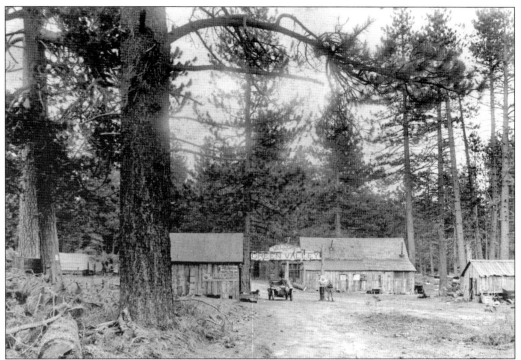

The Green Valley tollhouse was operated by the Tillitt family and was located at the entrance to the present-day United States Forest Service (USFS) campground. The route used in those days took travelers over the Snow Slide Road, since the Arctic Circle was not completed on the north slope of the mountain until 1924.

There are no natural lakes in the San Bernardino Mountains except for Dollar Lake, formed from a pocket glacier, and Baldwin Lake, which is a lake only when nature wishes to make it so. A dam was built to hold the water in Green Valley back, and by 1925, there was a lake there—higher than Big Bear Lake, but covering only 10 acres.

The first road into the San Bernardino Mountains was built by the Mormons in 1852 and ascended Waterman Canyon. Later travelers referred to it as a trail rather than a road. The building near the center of the photograph, the Panorama House, was a rest stop where one could buy gasoline, supplies, and refreshments.

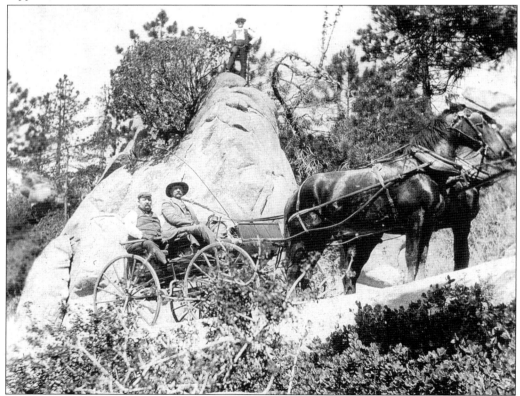

On this trip, Alywin, Lewis Murray's great-grandfather, traveled by buckboard with three other companions to Bear Valley and Doble. (Courtesy Lewis Murray.)

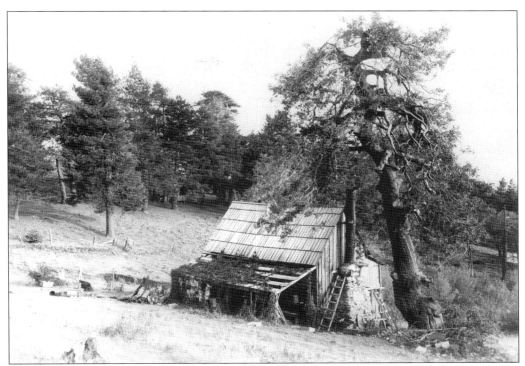

This is the cabin of Alfred "Fred" Heap, who was—according to his family—a hermit. But he invited travelers in for apple pies made from his own orchard and a spot of home brew to wash it down. Only a trail ran by his cabin then; now Highway 18 crosses to the left of this photograph taken about 1910.

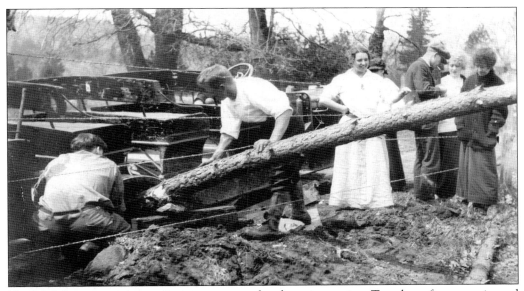

No AAA here to come to assistance or even a local service station. Travelers often experienced flat tires from the unpaved roads and carried two or more spares. Without the use of a floor jack, these men improvise with a log, which was used as leverage to make repairs.

Albert Powers loved the mountains and opened this store in the 1920s. His son Ray remembers spending some of his happiest days working here. It was located just north of the present Deer Lick Lumber. The large tree, no longer there, was a favorite attraction and photograph opportunity for tourists.

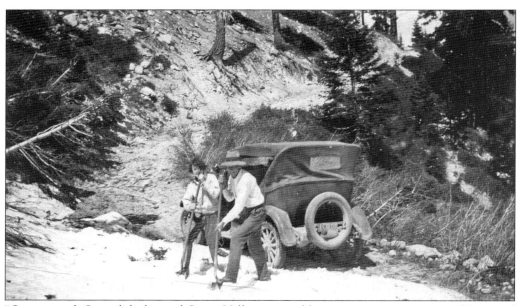

"Over towards Snowslide, beyond Green Valley, we would get snow sometimes up until June and sometimes even later," remembered Ray Powers in 1976. "We could fill up the car with snow or ice, cover it with oilcloth and deliver it in our Dodge to fill up ice boxes and keep the pop cool."

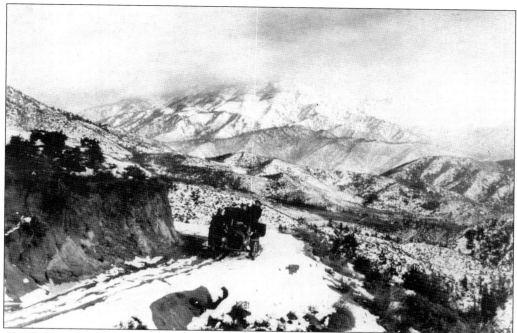

The dedication of the 101 Rim of the World Highway was held on Sunday, July 18, 1915. Travelers in the winter often found it difficult or impossible to drive. This was decades before four-wheel-drive vehicles, when many mountain roads were not paved.

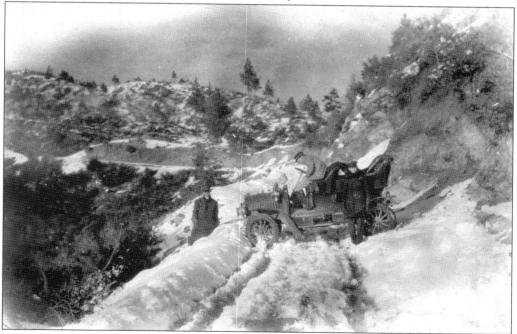

Apparently these travelers did not come well enough prepared for their visit to the Rim of the World Drive, even though the automobile is equipped with chains (barely visible). The driver either tried to make a U-turn or slid off the road.

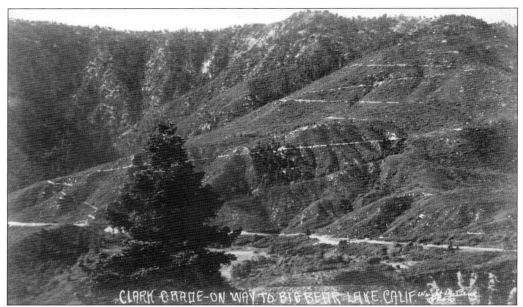

Hiram Clark owned a ranch near a road that he graded himself in 1910. Named after him, Clark's Grade was a tortuous switchback road, often closed due to landslides and washouts. The postcard message on the back of this photograph reads, "Dear Folks, We are having a fine time. The boys caught 19 fish this morning. How is that? With best wishes, Mr. and Mrs. Stover. Sep 17, 1915."

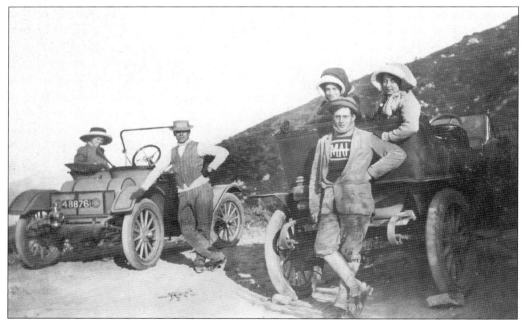

It is believed that Walter Kohl was the first to make it up Clark's Grade in an automobile. Sometimes tire chains were added to give better traction up routes whose builders had only planned for animal and wagon use—having never conceived of the invention of a self-propelled vehicle.

In 1899, Gus Knight Jr., along with Hiram Clark, opened the Bear Valley and Redlands Toll Roads. Knight was influential in the development of the Big Bear area, building lodges and developing subdivisions. Big Bear was originally referred to as Pine Knot.

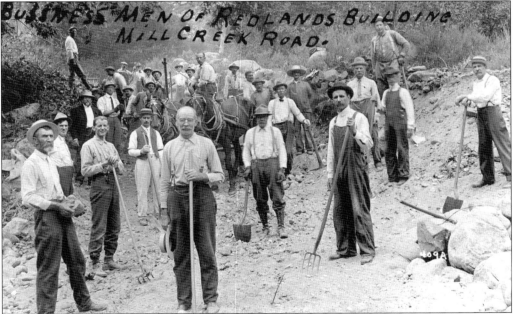

In 1913, the San Bernardino County Board of Supervisors, along with businessmen from Redlands, toured Mill Creek Road by automobile and burro and voted to fund a realignment of the road—one of many such road reconfigurations that would follow. County supervisors and businessmen have not been spotted lately working on any roads.

Joseph Tyler wrote in his 1870 diary, which he kept at his Grass Valley sawmill near Little Bear Valley (now Lake Arrowhead), that he cut logs to make road beds. This photograph, taken about 1915, seems to show a road bed made of logs creating an "improved" surface. It appears that this is the road that came over the Snow Slide Road, which would have brought visitors up Waterman Canyon or City Creek along the 101-mile highway through Green Valley to Fawnskin. These roads, as they are today, were difficult to maintain after winter and spring storms. Even with today's modern equipment, portions of roads are often closed. For instance, the infamous "narrows" between the Crestline turnoff and Lake Arrowhead and the Arctic Circle are often closed as CALTRANS struggles to remove boulders, shore up crumbling mountainsides, and fill in washouts, which can carry pavement away, leaving no visible remains of there having been a road at all.

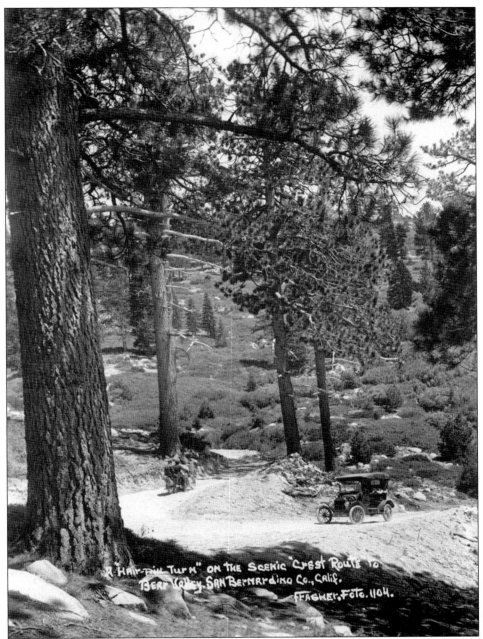

A "Hair-Pin Turn" on the Scenic "Crest Route" to Bear Valley, San Bernardino Co., Calif. FRASHER.Foto. 1104.

This early photograph on the "Scenic Crest Route to Bear Valley," taken from an unidentified location, was the product of Frasher Foto. The trip from Los Angeles or Pasadena along baseline took an entire day. Visitors left early in the morning and would have planned to stay the night either camping outside or in one of the new resorts that became popular as soon as roads became reliable. By the time this photograph was taken, automobiles could come up one of several routes—Waterman Canyon (Old Mormon Trail) across the Rim of the World Highway, City Creek (the original roadbed of the Highland Lumber Company), Santa Ana Canyon, or the desert route through Cajon Pass and Victorville and eastward to Johnson Valley, up past Baldwin Lake.

After the long and challenging trip up one of the unpaved mountain roads, visitors were rewarded with the gorgeous view of the newly created lake in a beautiful valley that would attract visitors and permanent residents year-round. Whether it was to fish, boat, hike, or just breathe the pure, mountain air, people who came once often returned with friends and family. Some built cabins or purchased large tracts of land and opened businesses. Others brought boats or snow skis, and everyone returned home to tell friends and neighbors about that wonderful valley up in the San Bernardino Mountains. The popularity of the valley has increased the permanent population from the few dozen who lived there in the beginning to 21,000 in 2006. On a peak day, the population can reach 100,000 visitors.

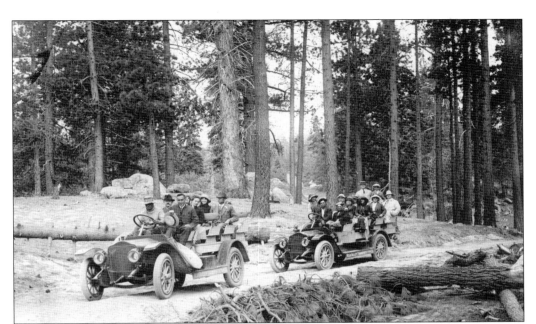

In 1912, brothers Max and Perry Green, along with Kirk Phillips, formed a partnership and created the Mountain Auto Line. They employed the Howell Brothers of San Bernardino to convert White trucks for passenger use. It is doubtful these vehicles came up the mountain carrying the loads pictured here.

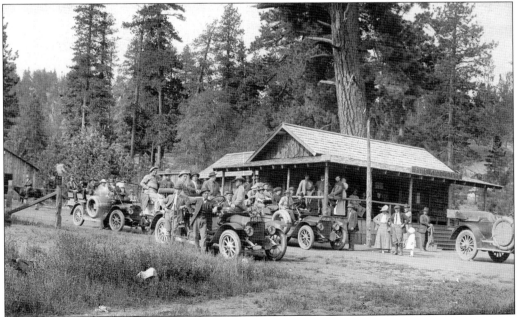

A popular topping place for travelers to refresh themselves after the long trip up the Santa Ana Canyon's unpredictable grades was the Pine Knot Store, within walking distance of the Big Bear Valley. This is one of the first stores to supply visitors to the new resort, allowing them to stay for longer periods of time.

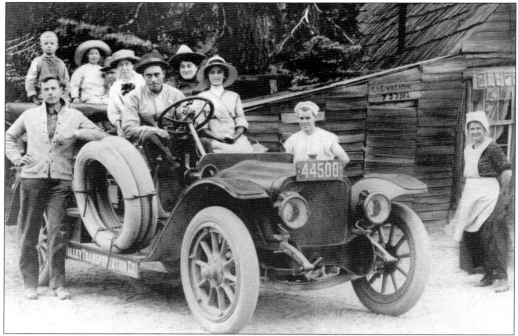

Since the 1880s, one of the most popular places to visit was Bluff Lake, at an elevation of 7,575 feet. These travelers ride the Bear Valley Transportation Company's shuttle. They have evidently stopped for some refreshments after ascending the Santa Ana Canyon's precipitous grade before the short trip into Big Bear Valley.

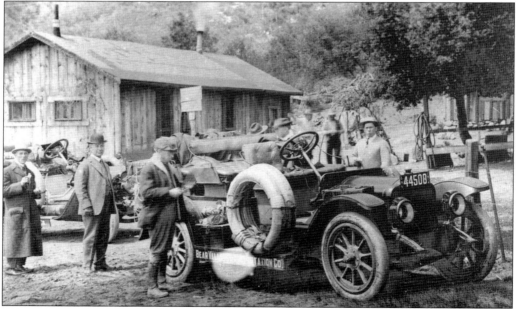

In May 1913, the Shay family began the Bear Valley Transportation Company, headed by Ernest "Ern" Shay, with regular day trips into the mountains. Due to improved roads, Shay vehicles could make the journey in a single day, opening the Big Bear Valley to some of its first tourists.

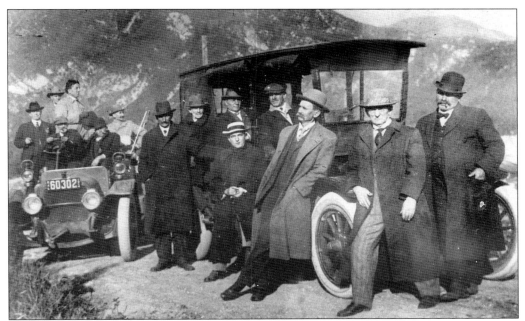

The road up the Santa Ana Canyon was often washed out, and the Edison Power Company supplied the labor in 1910 in an attempt to improve it. F. J. Culer, of Forest Home Resort, moved the road to the north side of the stream above water level. In 1913, the San Bernardino County supervisors toured the route by automobile and burro to search for better access to the Big Bear Valley.

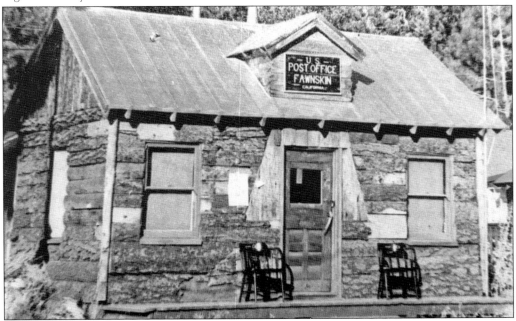

Fawnskin Post Office, pictured here around 1920, is one of the few buildings still remaining from that era. In the *Postal History of San Bernardino County*, Lewis Garrett notes that the original name was Oso Grande Post Office (March 22, 1918), with Nels B. Burkey as postmaster.

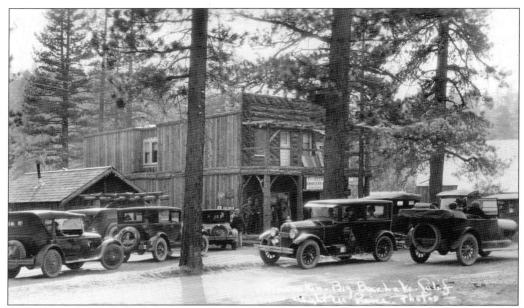

On the north side of the lake, Fawnskin consisted mostly of federal land, while the south side was privately owned. Here is early Fawnskin, with the post office (center right) partially hidden by automobiles. The area still maintains its charm, and many of the original buildings, including the post office, remain from an earlier period. The name of the meadow originated when hunters that had camped there killed a number of deer and stretched the hides on trees.

The bridge across Grout Creek empties into Grout Bay on the north shore. Early travelers saw deerskins stretched between trees, where hunters had placed them to dry, and soon the area became known as Fawnskin. This 1940s photograph shows the area as it appeared then—very much as it is today.

Four

PEOPLE CAME

The first visitors to Bear Valley were American Indians. Next the white man came to hunt and search for natural treasures, including gold. As long as there was gold to mine, people came and stayed. Once the mines were played out and the cold winters set in, folks returned to milder climates. However, the natural beauty of Bear Valley would remain an attraction for many. The narrow trails, together with the rough terrain, made early travel difficult and long. With the advent of better roads and machines (i.e. early automobiles), accessibility to this naturally scenic area attracted people by the thousands.

This chapter concerns the arrival of people who came to relax, fish and hunt, and to enjoy the picturesque beauty of Bear Valley. With the arrival of visitors, came the entrepreneurial spirit that would provide for their needs. Visitors required the development of camps, lodges, and hotels. This chapter explores some of the countless early facilities that served the needs of the first visitors and settlers.

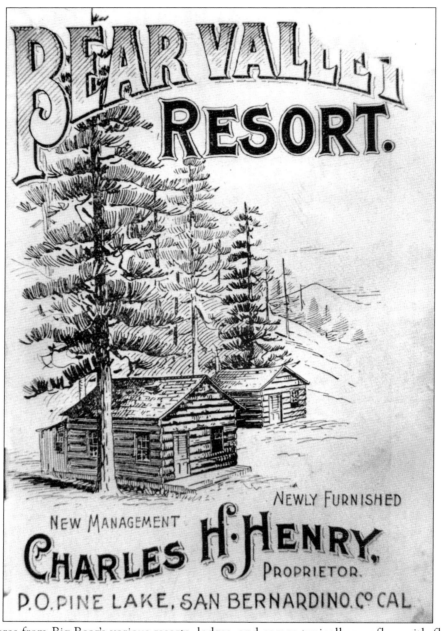

Brochures from Big Bear's various resorts, lodges, and camps typically overflow with flowery euphemisms to attract guests to their establishments. This 1890s brochure for Bear Valley Resort extols "new management" and "newly furnished" facilities and features the proprietor's name, Charles H. Henry, in bold type. Henry, Gus Knight's brother-in-law, also operated a small store adjacent to the Bear Valley Hotel. The Pine Lake (Pinelake) Post Office operated from 1891 until 1905. Seven years later, new owners purchased the property and built the Pine Knot Lodge. The new post office at that site was named Pine Knot. It became the main post office in Bear Valley; many early postcards bear that cancellation. In 1938, a more descriptive name for the area was adopted—Big Bear Lake.

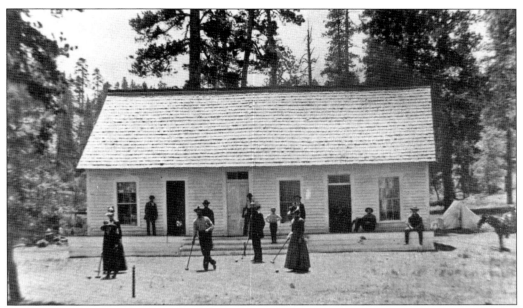

In 1867, Augustus Knight Sr. came to the San Bernardino Mountains. In 1875, he was involved in construction in Bairds Town. His son Gus Knight Jr. soon realized the resort potential for visitors to the area and, in 1888, opened the first hotel in Bear Valley, called the Bear Valley Hotel. This 1895 image depicts the Bear Valley Hotel built by John Metcalf and Gus Knight.

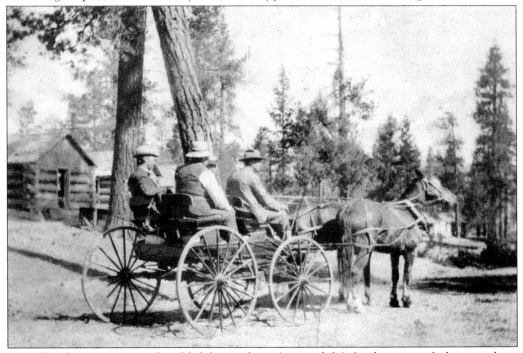

Not all early visitors arrived and left by machine (automobile). In this original photograph, c. 1904, Alywin Clarke and his party of four are leaving one of the camps in Big Bear, possibly Pine Knot. (Courtesy Lewis Murray.)

Staying in a lodge or hotel was not for everyone. Many early visitors enjoyed camping out, as do visitors today. In this early-20th-century photograph, a man and his son appear to be enjoying the mountain life. Many campsites were available with facilities, including a tent or tent site, parking for your "machine," and stores and post offices often nearby.

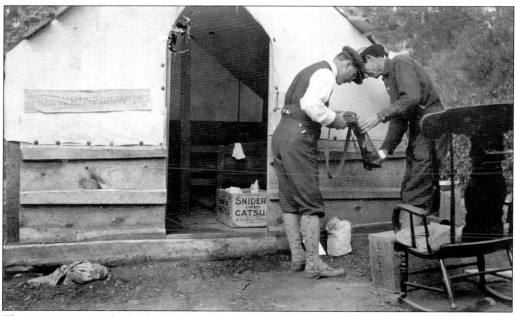

The inscription on the back of this early postcard states, "Holcomb Valley—1915." By then, the early mining boom of Holcomb Valley had long since faded. But speculation suggests that these gentlemen were still searching the region for their fortunes. The sign on the tent at the left of the entrance reads, "The Whip-Por Will." The two early wooden boxes visible in the image were once used for Sniders Catsup and Mount Vernon Evaporated Milk.

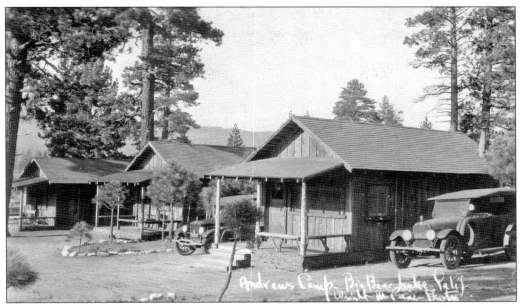

Andrew's Camp, on the south shore of Big Bear Lake, is one of the many camps that sprang up during a period of great growth in Bear Valley between 1917 and 1925. Located not far to the east of Stillwell's Resort, the image depicts a rather roomy cabin with front porch and parking next to it.

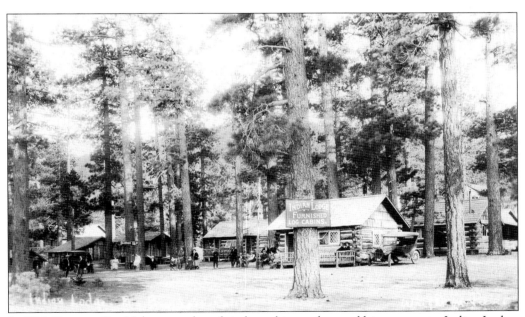

In 1916, Burnese Gay Holmes purchased six log cabins and named his new estate, Indian Lodge. He then added more cabins, all of log construction. B. G. Holmes eventually added real estate sales to his Big Bear activities. However, he is better known for writing two small books on the history of Bear Valley, *Letters of the Early Pioneers of Big Bear Lake* and *Tales of the Pioneers of Big Bear Lake*.

Displayed here are panoramic images of Baldwin Lake, above, and Baldwin Lake Tract Office, below. The lake image from the north shore is taken from land on the Shay Ranch. The Shay brothers opened the tract office visible in the image and sold land on the north shore. Perhaps the gentleman standing at the door of the tract office is one of the Shay brothers. Subdividing

and selling lots in the Big Bear area was rampant beginning in 1916, when the Bear Valley Mutual Water Company formed the Bear Valley Development Company. "The sound of the hammer and saw is heard on all sides and buildings are going up just as rapidly as possible to put them up," read the *Redlands Daily Facts* of May 23, 1919.

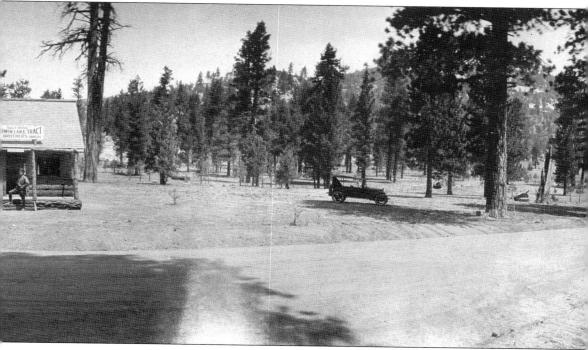

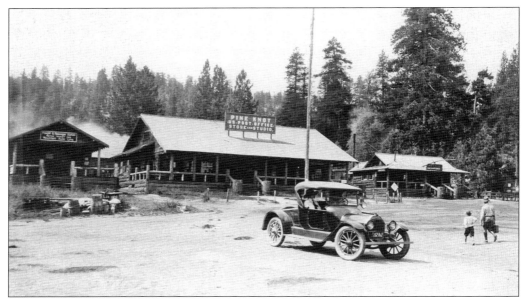

The Pine Knot Post Office was located in the store and studio building at this major resort, located south of the present village. Fred C. "Dad" Skinner was the postmaster here from 1916 until 1928. At the left is the Mountain Auto Line's freight and passenger station, and at the right is the Pine Knot Lodge office. The name remained Pine Knot until 1938, when it changed to Big Bear Lake.

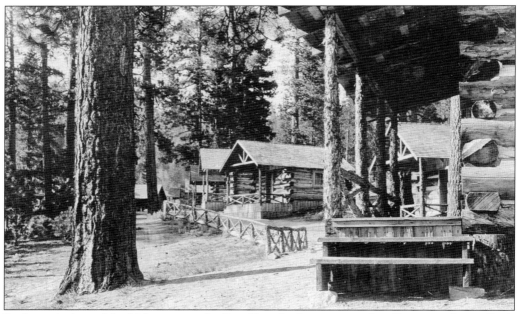

In the early days of the 20th century, the Pine Knot Lodge was considered luxurious living. Each of the numerous little cabins contained a small wood stove, chest, washstand, chair, and bed. Until about 1915, kerosene lamps were used for lighting, and there was hot and cold running water and a tub for bathing.

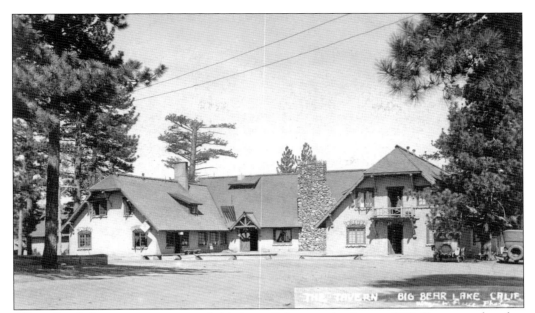

Albert Brush began construction of this beautiful tavern in August 1917. For many decades, this was the most exclusive and expensive place to stay in Big Bear Valley. This historic tavern is still in existence on the south side of Big Bear Lake and has functioned as the Presbyterian Conference Center for many years.

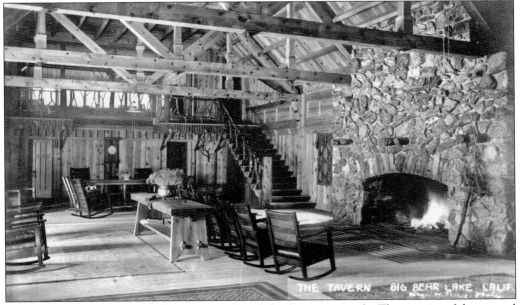

The tavern features a beautiful view of Big Bear Lake from its veranda. The interior of the central hall features a huge fireplace and massive roof trusses. The message on the back of this postcard states in part, "Thought I was as near Heaven as I could get, but I stubed [sic] my toe and fell, and sprained my arm and have to get well to write this. Will be all right soon."

❖ BIG BEAR LAKE ❖
Summer and Winter

This image from an early advertising brochure was intended to lure visitors to the Big Bear Lake area. Many such brochures were produced by land developers, realtors, and resort owners to attract business. The full-page layout includes glimpses of the lake, tobogganing and fishing, and presents both winter and summer fun. The upper right image shows a couple of hikers pausing to relax under a giant rock in the Big Bear area. A hike can reveal countless sightings of these granite monoliths: Castle Rock, Balancing Rock, Measuring Rock, rocks once used as forts, rocks revealing or concealing mine entrances, and rocks where lost mines were alleged to exist. If only the rocks could talk, imagine the tales they could tell of Big Bear's history?

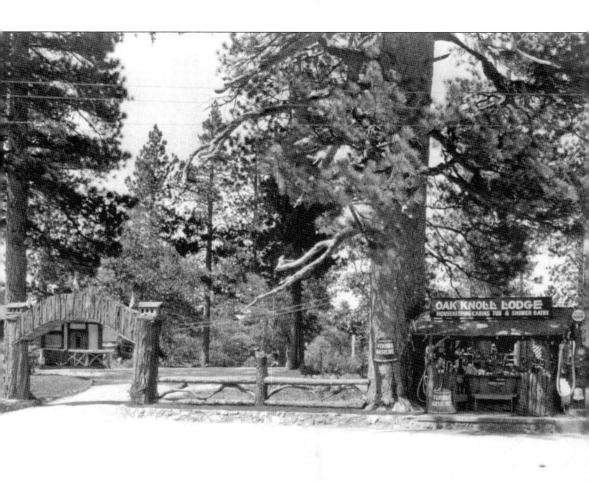

The earliest buildings of this still functioning lodge date to 1918. The oldest structure was originally a home built for Ernest G. and Anna Augustine and is now a rental cabin. Most of the cabins were built between 1918 and 1921. The lodge is located at the top of Mill Creek Road at the intersection of Tulip Lane. Mill Creek Road is historically remembered as the roadway of the famous switchbacks. In 1927, Roy and Elizabeth Laurence bought the lodge from the Augustines. The lodge featured the first gas pump (Ventura Gasoline), which one could see upon entering the Bear Valley on Mill Creek Road. The magnificent wood arch featured birdhouses on each pillar supporting the arch. Beautifully located on a wooded hill, the lodge enjoys the serenity of being away from the busy highway, but is only a couple minutes drive from the heart of the village. (Courtesy Chuck Lawrence.)

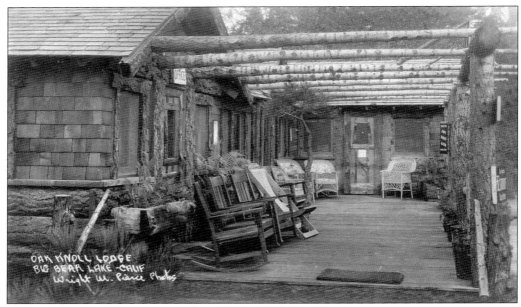

This is an early image of the veranda or porch at Oak Knoll Lodge. Today this has been enclosed and functions as the lobby for the historic lodge. Oak Knoll offers every modern convenience to its guests, while retaining all of the unique charm of its fascinating past.

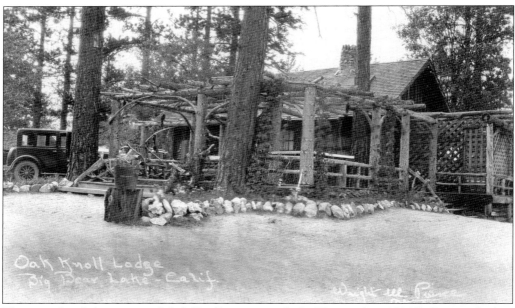

The same family has operated Oak Knoll continuously for 78 years (as of 2005). During the late 1930s, Oak Knoll Lodge became the first resort to use butane gas for cooking. A swimming pool was added in 1957, and additional modernizations have been continuing through the years. This is the original Oak Knoll cabin.

Fred Jakobi owned the Fawnskin Market and rented several cabins along the highway east of the store. The building to the right of the lodge is the Fawnskin Post Office, which opened in 1918. In 2002, the site was purchased by movie stars Shirley Jones and Marty Ingels and, through their generosity, has been dedicated as a community park.

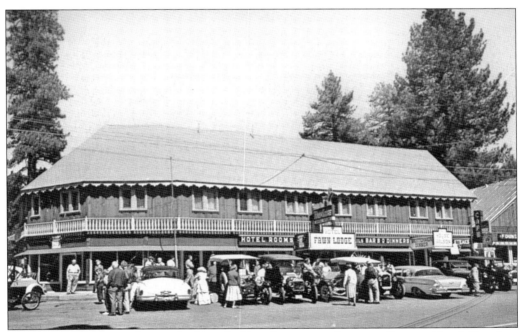

This very impressive multistory building had hotel rooms on the upper floors, with a lobby, drug store, hardware store, real estate office, and restaurant below. Built in 1917, it has been extensively altered over the years, both inside and out. A popular steak house operated there in the late 1970s, but the big building has been unoccupied ever since.

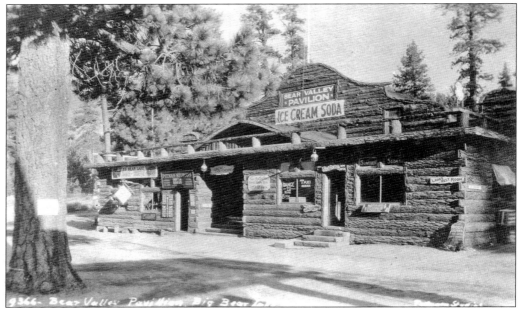

In 1918, the unusual Bear Valley Pavilion was built by Dad Skinner and Ed Mitchell in the heart of the growing village of Pine Knot. The pavilion contained a large dance hall, where dances were held every night during the summer. The pavilion once stood on today's Village Drive, just opposite Bartlett Road.

Early travelers to Big Bear wait for the Mountain Auto Line (later the Motor Transit Company) to pick them up at Pine Knot. The automobile line carried passengers from the Pacific Electric station in San Bernardino to Skyland, Squirrel Inn, Pinecrest, Strawberry Flat, Little Bear Lake, and Big Bear.

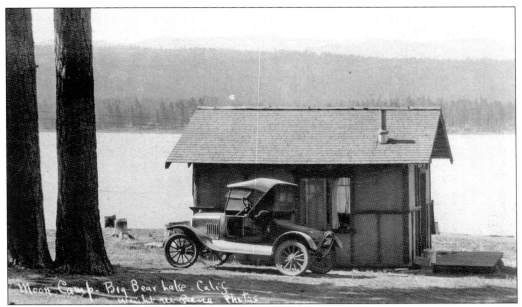

Located on the north shore, the unique Moon Camp store, office, and restaurant was built to conform to a sharp curve in the highway. Guests stayed in large buildings across the highway. The camp had a gas pump and boat landing. An automobile ferry ran from here to Pine Knot before 1924. This interesting camp was destroyed by fire in August 1951.

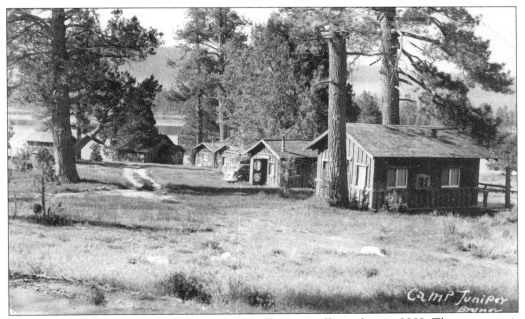

Long abandoned, the Camp Juniper store and office was still standing in 2002. The gas pump is long gone, as are the half-dozen rental cabins across the highway. The small boat landing had rentals, when the lake was high enough. The Minnelusa Post Office was here between 1928 and 1940 and was operated by Nilsina Sandberg.

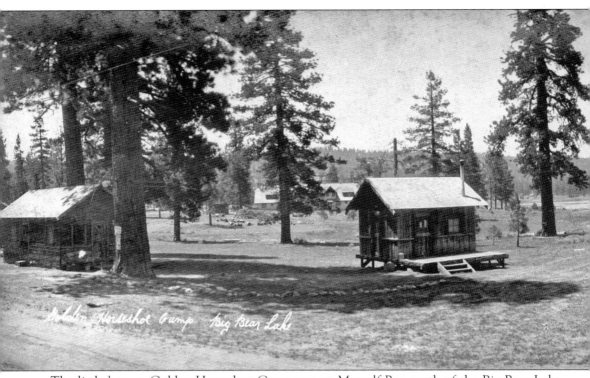

The little-known Golden Horseshoe Camp was on Metcalf Bay north of the Big Bear Lake Tavern—today's Presbyterian Conference Center. The Big Bear Tavern is barely visible in the background just behind the cabin near the center left. A. H. Small was the proprietor. The sign at the entrance states, "Golden Horseshoe Camp, A. H. Small, furnished cabins, boats." He and

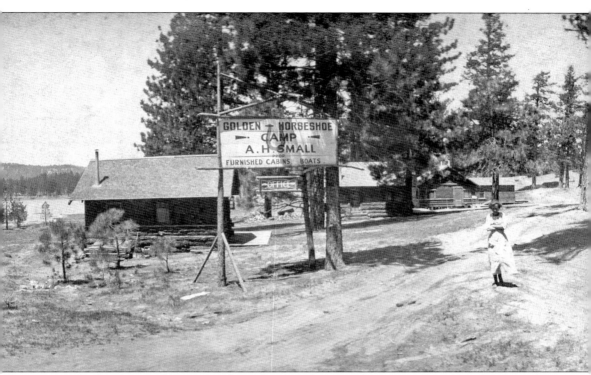

a partner built cabins and boats to order. A lovely lady is posed on the road at the right, dressed in clothes typical of the period. Electricity came to Pine Knot in 1922; since no lines are visible, this image was taken c. 1920.

Pictured here is a wonderful early panorama of Eagle Point, which was named for the bald eagles that returned here each winter. Today Eagle Point is one of the more upscale residential areas on Big Bear Lake. The cottage in the foreground still stands. Years after this photograph was taken, land was offered for sale in Eagle Point by the Bear Valley Mutual Water Company. A sales brochure claimed, "You'll find resort living at its best in the new Eagle Point subdivision No. 3. Paved roads, electric lines, water lines, and fire plugs are included in the price of each lot, and

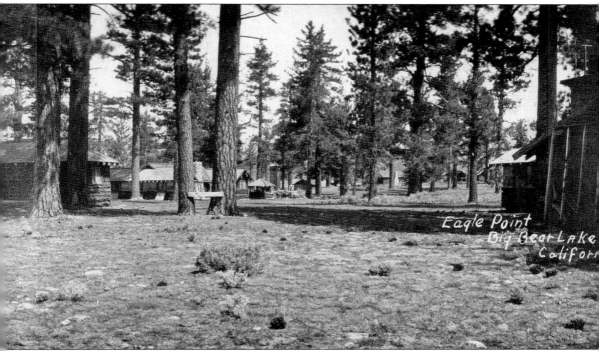

Eagle Point
Big Bear Lake
Californ

to prevent future digging in the paved roads, water is extended to each lot. Telephone service is also available. In addition to one of the most beautiful view points on Big Bear Lake, it possesses one of the finest stands of large and small pine trees, together with some of the historic juniper trees." Two hundred twenty-one lots were offered for sale in smog-free Big Bear Lake to buyers desiring to build homes in one of the area's most exclusive subdivisions. Almost every lot offered buyers a lake-front or lake view.

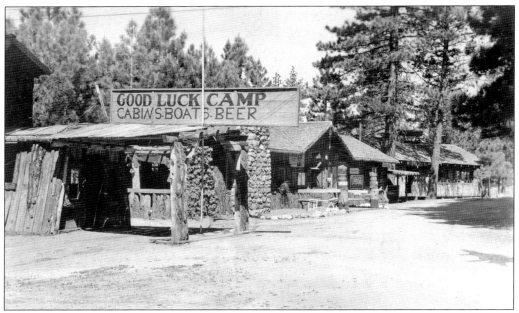

Located on the north shore, the Good Luck Camp had a nice store, boat landing, cottages, and a tent area. Additionally the camp sign also mentioned "beer," a sure hit with many of the guests—and a hit during Prohibition! A large horseshoe welcomed guests to this camp.

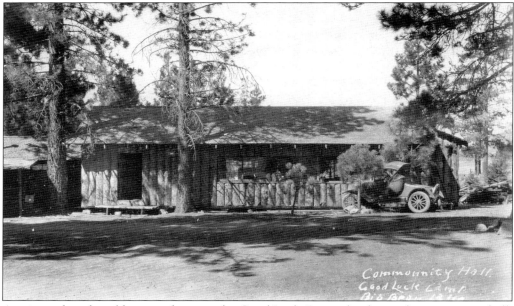

As pictured in this old postcard image, the Good Luck Camp also featured a community hall, which burned to the ground in the late 1920s. Images of the old community hall are quite rare. (Courtesy Jim and Beverly Miller.)

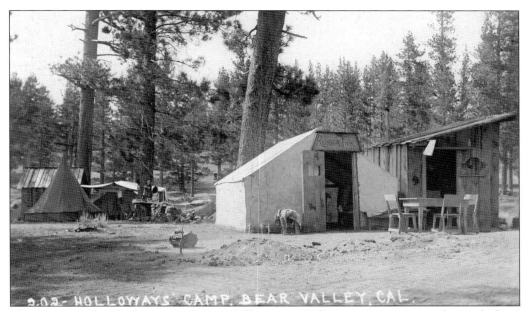

This is an excellent look at an early Bear Valley camp. Holloway's Camp was on the south shore of Big Bear Lake just across the lake from Fawnskin. The image is interesting for the different styles of accommodations pictured.

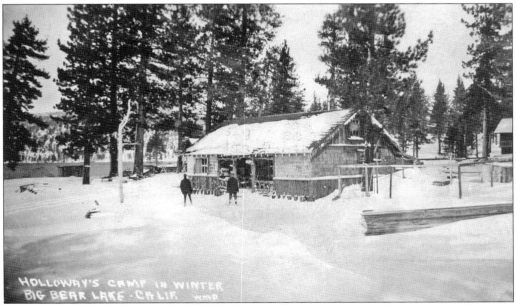

In this postcard of Holloway's Camp, mailed in May 1921 from the Pine Knot Post Office, one can see its nearness to Big Bear Lake. The message on the back states in part, "This is how it looked the day before we got here. Had a hard time coming up, too much load, and it rained cats and dogs. Lots of snow around and ice in the house."

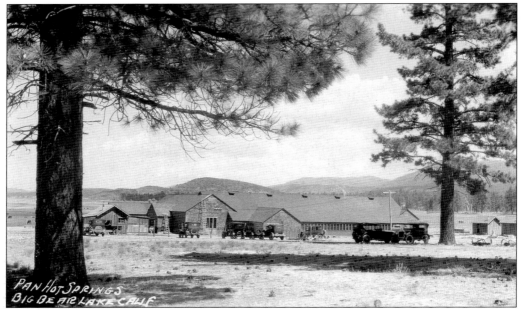

In 1921, Emile C. Jesserun purchased 40 acres of the Shay Ranch, including hot springs known and used by the Serrano Indians for centuries. He further developed the springs by drilling wells. In 1924, Jesserun finished building the largest hotel in the valley, Pan Hot Springs Inn. Featuring a beautiful lobby, dining room, ballroom, and two large indoor and outdoor swimming pools, with private therapeutic baths available, the inn burned in 1933. Only the two swimming pools remained open; they were dismantled after the 1992 Northridge earthquake.

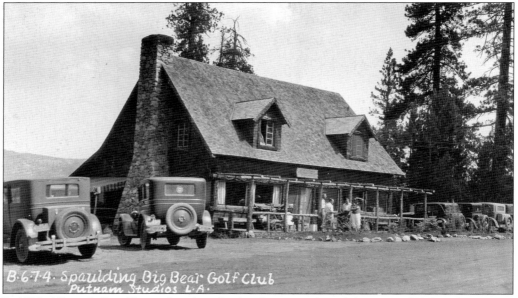

In 1923, Albert S. Spaulding, a Los Angeles developer, purchased the original IS Ranch property from the Talmadge brothers; the area is called Moonridge today. The 1,440 acres were subdivided into lots, and roads were built. Spaulding Big Bear Golf Club, a clubhouse with an 18-hole golf course, was constructed. In this early view of the clubhouse, none of the vehicles are Fords.

This insert, from a mid-1920s map by the Automobile Club of Southern California, reflects much early Bear Valley history. Most of the resorts and camps pictured here have long since disappeared. It would seem that there were almost too many resorts and camps to have been supported by Bear Valley in the early days. Many of these are now remembered only by the images that still remain. A few of the early resorts still exist on their original sites but have been modernized and now reflect a different name.

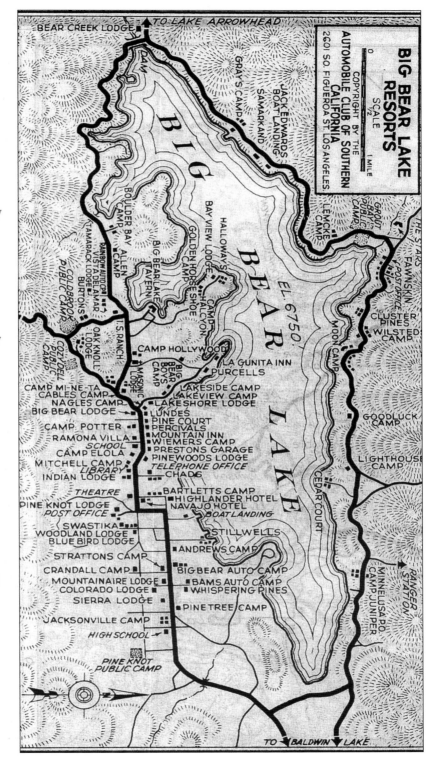

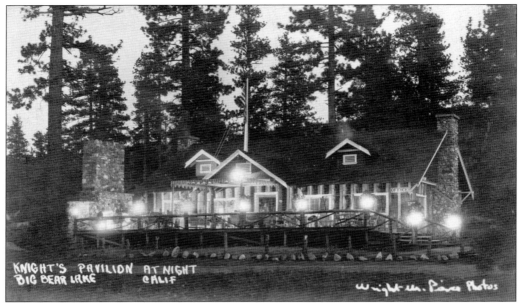

KNIGHT'S PAVILION AT NIGHT
BIG BEAR LAKE CALIF

The message on back of this postcard reads, "Big Bear Lake—Knight's Camp 7000 ft altitude 8/20/23. Mother Came up here Thursday on the 'Rim of the World' trip by stage all the way from L.A. Left at 7 a.m. and arrived here at 5 p.m. The air is wonderful up here but so cold at night—just like October back home—my hair was so full of electricity could hardly comb it. I am going to take the boat trip around Big Bear Lake this a.m. This is one trip I will not recommend to you as one rides too close to the edge of high mountains all the way up. Going back to L.A. tomorrow. Love Etta."

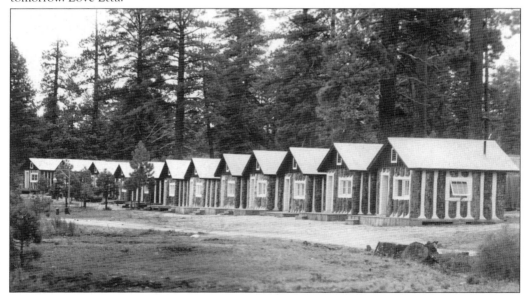

In 1906, Gus Knight Sr. passed away, and Gus Knight Jr. inherited 40 acres east of Pine Knot. Here he established a camp that would remain popular for many decades. The camp had 40 cabins, a pavilion, kitchen and dining room, garage, and general store. The camp remained until the early 1970s, when the buildings were razed for a mobile home park and other commercial structures.

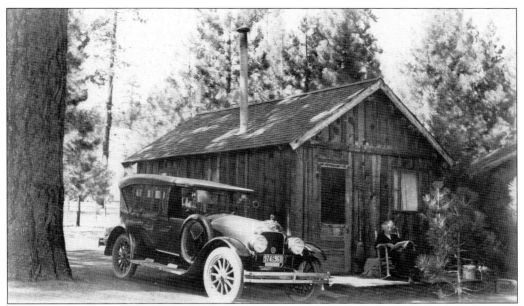

The back of this postcard, which was not mailed, states, "This is our cabin at Big Bear Lake where we spent a delightful week in August. Notice the tree in front. Birds came there to get tiny bits of bacon rind, cantaloupe seeds, etc." A middle aged woman relaxes on the porch. The year on the license plate of the classic touring automobile is 1923.

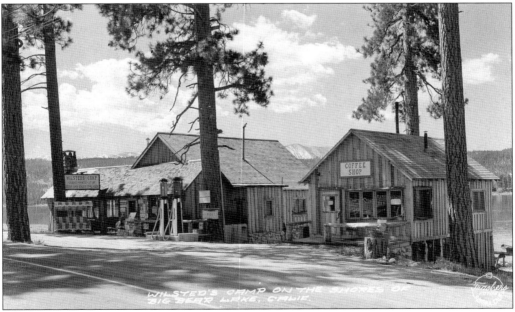

Located on the north shore, Wilsted's Camp had a store, coffee shop, boat rentals, cottages, and two gas pumps next to the highway. The coffee shop featured roast, steaks, and baked ham. Three of the four signs on the store front featured tobacco products, including Prince Albert, Camels, and Phillip Morris.

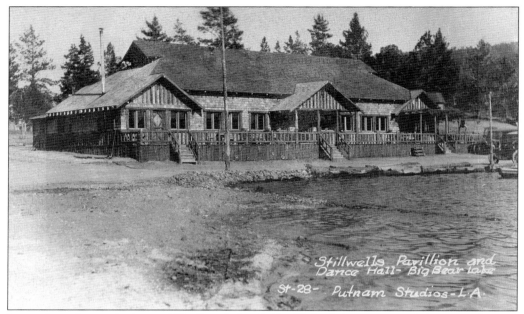

Located on the south shore of Big Bear Lake, Stillwell's had their inaugural dance in the new ballroom on July 1, 1921. Carl and Mamie Stillwell's dream to build a rustic ballroom was realized. This original ballroom was completely destroyed by fire in 1928.

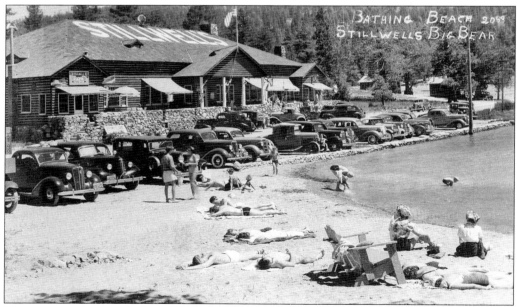

This image, taken in the late 1930s, is of the second Stillwell's, which met with a similar fate. On December 8, 1945, it burned down only six months after the new owners, Bert Ahlgrim and Wade Miller, had purchased the famed resort. Today this is the site of the Blue Whale Lakeside Restaurant.

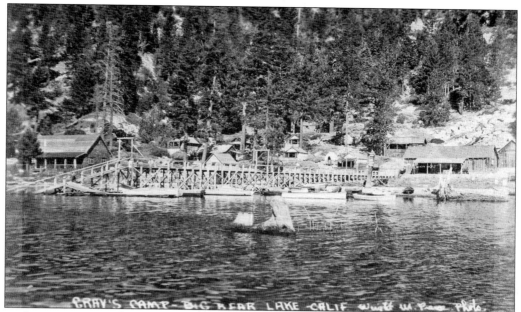

With a location near the dam on the north shore, there was usually deep water at Gray's Camp—even toward the end of summer when the lake would be at its lowest. This made Gray's a favorite with boaters and fishermen. The road from Fawnskin ended here until 1924, when it was completed around the lake.

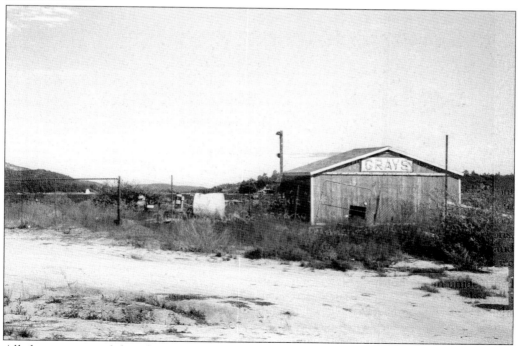

All that remains of this ghost camp are a lone building and the fading remains of the sign announcing Gray's. The new highway required the removal of most of the rental cabins at Gray's Camp, but the busy boat landing still operates.

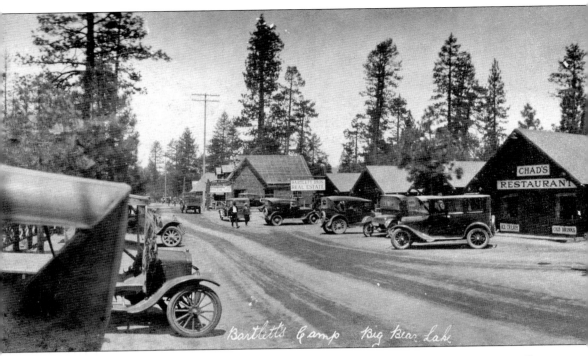

Featured above is a rare panoramic photograph, *c.* 1923, of the north side of the present Village Drive. This is one of the oldest pictures of downtown Pine Knot. Pictured here, from right to left, are Bartlett's Camp office, store, and service station, the prominent building in the foreground; Chad's first restaurant, opened in May 1918; an unidentified building; a barber shop; Bartlett

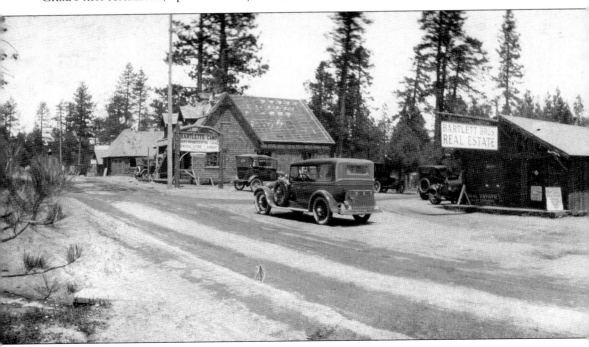

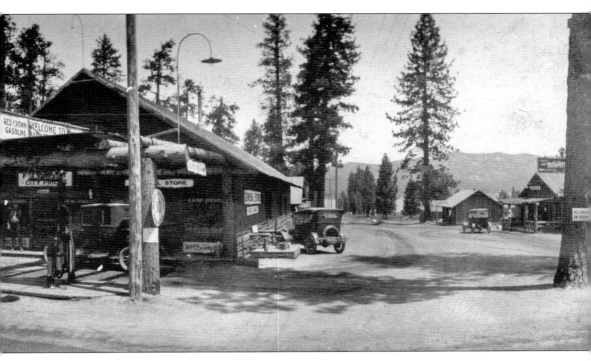

Brother's Real Estate Office; a narrow street that is now gone; a vacant lot; and Chad's new two-story restaurant. It is interesting to observe that of the 17 vehicles visible in this image, all are open cars except one Chevrolet sedan. The image below provides a better view of the buildings between Chad's first and second restaurants.

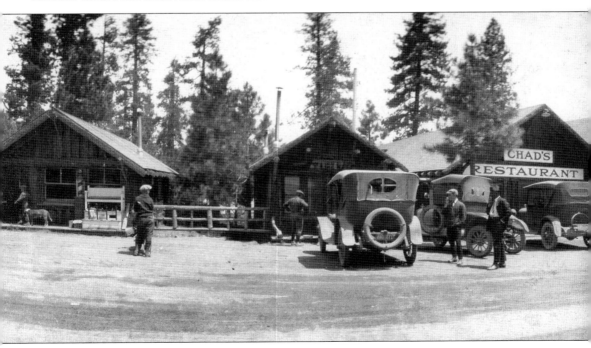

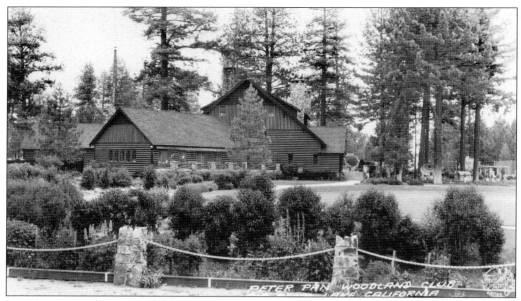

In 1930, a great four-story clubhouse was built to promote the major east valley development of Big Bear City—Peter Pan Woodland Club. It was designed and constructed by Guy Maltby, owner of the Bear Valley Milling and Lumber Company. Guy built hundreds of homes in Bear Valley. Many of the rock pillars, visible in the foreground on the left, can still be seen along Straightway, just north of Highway 30.

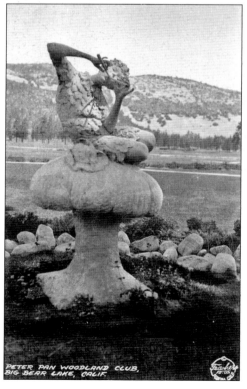

The symbol of the Peter Pan Woodland Club was a statue of Peter Pan, which stood in the garden and was sculpted by Fred Humphrey. However, far more prominent were the famous twin bears (see page 78), which Humphrey also created. The bears marked the west entrance to the new community on each side of Big Bear Boulevard's intersection with Division Drive.

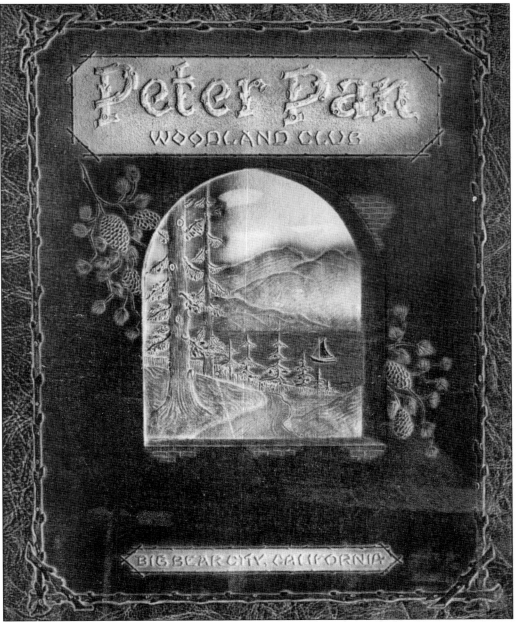

"In such a spectacle of loveliness is this 'Never Land come true?' Here has been dedicated a happy memorial to the thriving tribe of Peter Pan." The Peter Pan Woodland Club was created by Harry Kiener, who formed a corporation in 1925 to develop pristine mountain property that was part of the Shay and Barker Cattle Ranch. In 1934, lots with all improvements could be purchased for $269.90, with lifetime membership in the club and use of the golf course, tennis courts, swimming pool, gymnasium, and boating and fishing equipment. In 1932, an annual membership could be purchased for $100. This also obligated the member to annual dues of $7.50. Sadly the club caught fire in the early morning of June 19, 1948, and only ruins and ashes were left. Bear Valley lost its magnificent and irreplaceable showplace in less then one hour.

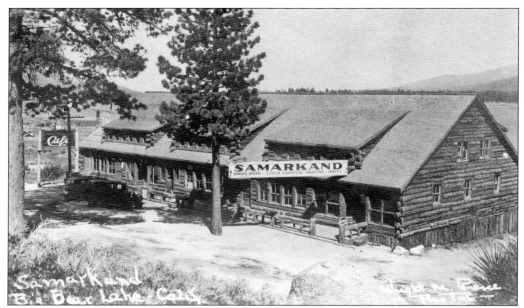

This postcard was mailed from Fawnskin in 1927. Located on the north shore, the beautiful Samarkand had a superb lakefront location with a dining room, fine ballroom, and hotel rooms. Built by Coy and Lex Brown around 1927, it was destroyed by fire in the fall of 1937.

The twin bears guarded the west entrance to Big Bear City for half a century until 1978, when CALTRANS removed them because the massive bases were a traffic hazard at the busy intersection. However, the bears remain standing in front of a nearby commercial business.

Five

DAMS

The lingering question of whether natural lakes existed in the San Bernardino Mountains requires more space than this book allows. However, this chapter deals with the dams that are there today. In 1910, the Bear Valley Mutual Water Company concluded that a new dam should be constructed to increase Bear Valley reservoir's water. The greater capacity was required for the growing citrus industry in the valleys below, in both San Bernardino and Riverside Counties. The company selected John S. Eastwood to build the new dam. Eastwood's dam would be about 300 feet further downstream from the rock dam. However, the unusual design of Eastwood's dams (he built 17 before his death) did not inspire public confidence. His multiple-arch dam design required less cement and work went faster than on other dam projects. The dam was completed the following year. Eastwood's design proved its strength, when, in January 1921, an earthquake shook the dam to the point that dam keeper B. T. Weed watched it vibrate "from eight to ten inches." He was happy to report that there "wasn't a crack in it" when he inspected it a day later. In 1924, John Eastwood ironically drowned in the King River in California while swimming near his retreat—the result of a heart attack.

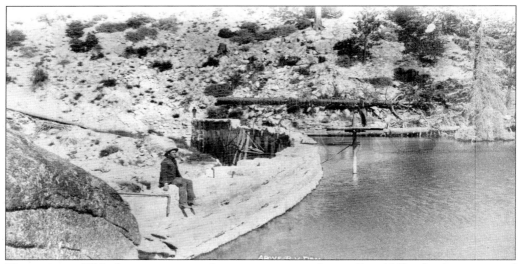

The year was 1883 when construction began on a storage dam in Bear Valley for the purpose of providing water to Redlands, San Bernardino, Highland, Riverside, and Colton. Frank E. Brown formed the Bear Valley Land and Water Company on October 2, 1883. Work stopped on the Bear Valley Dam in November 1884.

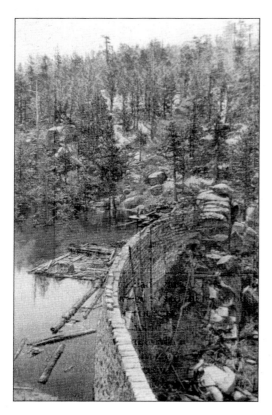

This is the first dam as it appeared when work stopped. As the dam's height increased, Frank E. Brown became very nervous about it falling over. When the workers started to put the last course of rock on the top, a terrible blizzard hit. He used the blizzard as an excuse to send them home. The dam remains unfinished.

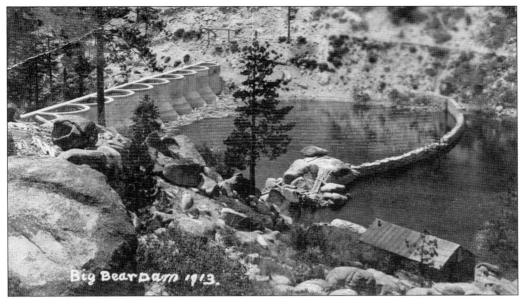

This 1913 photograph shows the 1884 dam and the "new" dam completed in 1912. At that time, there was no road over the dam, as today. The wooden structure in the foreground was a blacksmith shop. During World War I, the water company stationed guards on the dam to prevent acts of sabotage.

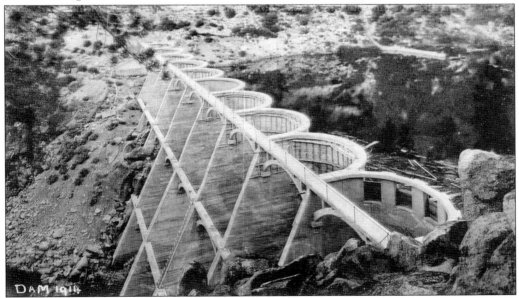

When the Eastwood Dam was completed, it stood 72 feet, 4 inches high; the original contract called for the dam to be 65 feet high. Unconfirmed reports indicate that Eastwood may have told Garstin that the buttresses were sufficient to hold another seven feet of water pressure, so Garstin told him to build to that height. When additional lands far behind the dam (which the Bear Valley Mutual Water Company did not own) became flooded, the company was faced with a real dilemma. It was not until 1922 that land swaps were arranged to acquire the land below the high-water mark. This image is from 1914.

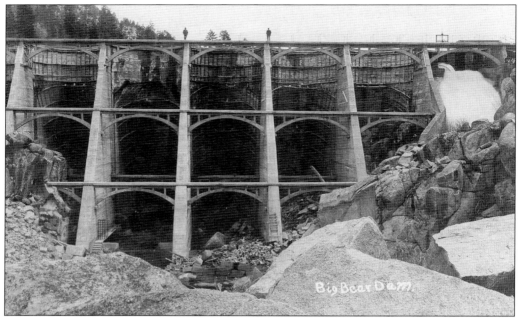

In this early view of the Eastwood Dam from below, the spillway is at the right, while two gentlemen pose on the dam for the photographer. The dam consisted of eight concrete buttresses and 10 arches. Cement and supplies for the dam were unloaded from railcars at Victorville and then hauled up the Cushenbury Road by horse teams.

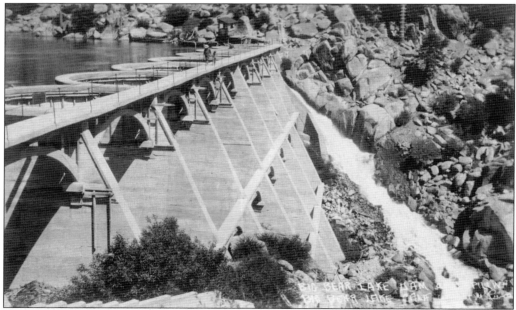

John S. Eastwood presented the Bear Valley Mutual Water Company with a unique design and a confident, low estimate to construct a 65-foot, multiple-arch dam. The board of directors accepted Eastwood's plan and appointed him superintendent of construction on April 7, 1910. By summer's end in 1912, the dam was finished at a cost of $138,000. This image is from 1913.

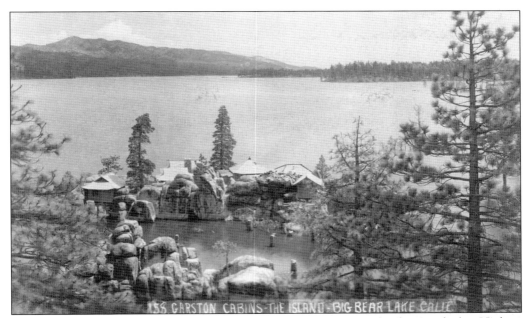

Early images of the island in Big Bear Lake refer to it as Garstin Island, named after Herbert H. Garstin. President of the Bear Valley Mutual Water Company, he was also resident of the first home on the island. The home's design, selected by Herbert's wife, Maude, was influenced by the Chinese architecture Maude loved. Her brother lived in China, and Maude visited him there frequently.

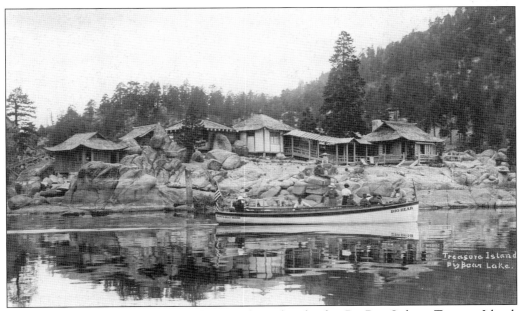

Postcards from Big Bear after the mid-1910s refer to the island in Big Bear Lake as Treasure Island. The reason for the moniker remains obscure. Many of the interior features of the Garstin home were imported from the Orient. The Chinese influence is also very visible from the outside in the garden statues, fountain, and entry gate near the boat landing.

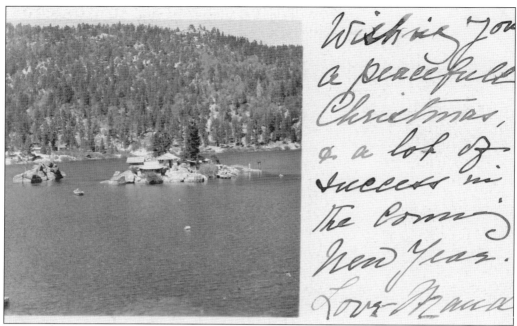

In 1910, plans for the new, higher dam were reviewed at the home of Herbert H. Garstin, the water company president. These plans revealed that a rocky island would be formed near the current dam. Garstin's wife, Maude, overheard the remark and later convinced Herbert to build a new Chinese–style home on the island. This Christmas message from Maude features their home on the island.

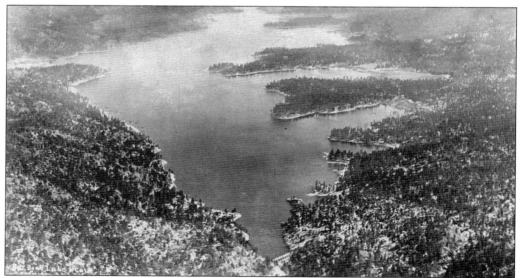

The Eastwood Dam is in the foreground of this aerial image of Big Bear Lake, looking east. The dam was 20 feet higher then the old, 1884 dam. As a result, the lake increased in size from 1,800 acres to 2,500 acres and nearly tripled the capacity from 25,000 acre-feet of water to 73,000 acre-feet.

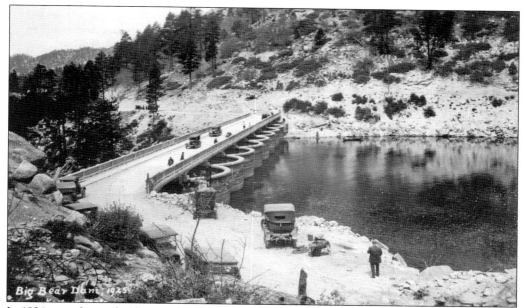

In 1924, a road over the dam on the new bridge was constructed and extended the roadway, for the first time, completely around Big Bear Lake. Two other sections of roadway were required to make this possible—sections from Gray's Camp on the north and from Boulder Bay on the south.

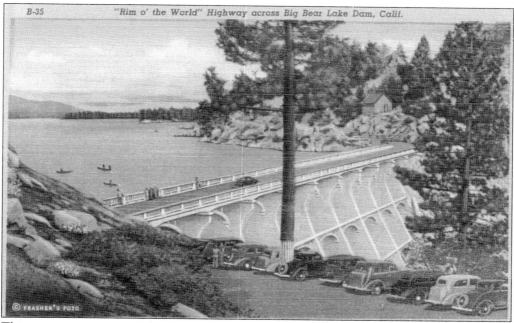

This contemporary postcard presents a picturesque and peaceful depiction of Big Bear Lake and the Eastwood Dam. The area has become a popular spot for photographers and sightseers. From the dam, a magnificent view of Big Bear Lake and the surrounding mountains is obtained.

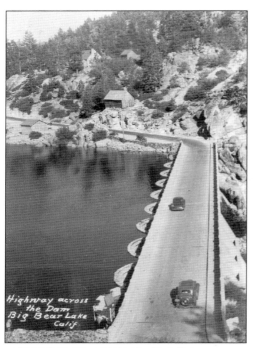

Completed in October 1890, the fireproof, stone home for the dam keeper is barely visible above the dam on the far left. It was not the first dam keeper's house, since he and his family lived at the construction camp on the north shore. After a couple years, a log house was built closer to the dam. The keeper and his family moved to their new home in 1887. In February 1890, this structure burned to the ground.

Following the purchase of the lake in 1977 by the Municipal Water District, water would no longer be released for irrigation, and there was no longer a need for a resident dam keeper. The water company returned the house to the USFS, with the hope of it becoming a museum. This hope never became a reality, and the home was stripped and made uninhabitable.

Six

COMMUNITY

A community developed in Holcomb Valley in the 1860s. However, a community must have common causes, such as sustenance, the passing of knowledge, and cooperation, for the good of everyone. When these essential elements are lacking, the community fails. This was the case in Holcomb Valley, Doble, and several other communities whose memories no longer exist except in history books.

One community, however, has continued to grow from a few small businesses into a large and secure town with the advantages of any city. In fact, Big Bear offers many amenities that can not be found anywhere in the Southern California region. It would be hard not to find what one needs in Big Bear Valley, thanks to the dedication of those who saw a future here for themselves, their families, and those who continue to enjoy its conveniences and pleasures.

The following rhetorical question is often asked: Where in the world can you go surfing at the beach in the morning and snow skiing on the mountain slopes in the afternoon except in Southern California?

While the weekends and busy summer days swell the population to almost intolerable numbers, there are still those quiet days, when tourists have gone home and left Big Bear Valley to its full-time residents, and peace descends over the area. One can then sit back and reflect on the luck of living here all year.

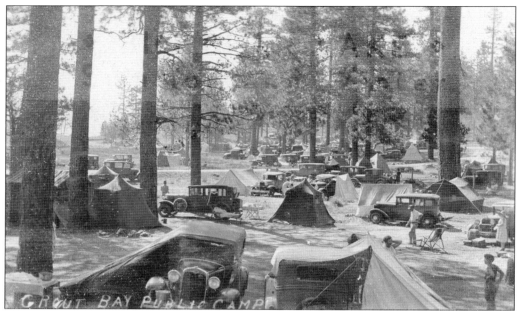

Grout Bay near Fawnskin has always been one of the most popular campgrounds on Big Bear Lake and has seen continual use since the earliest days—except when it floods during a heavy winter. This photograph postcard is dated September 24, 1932.

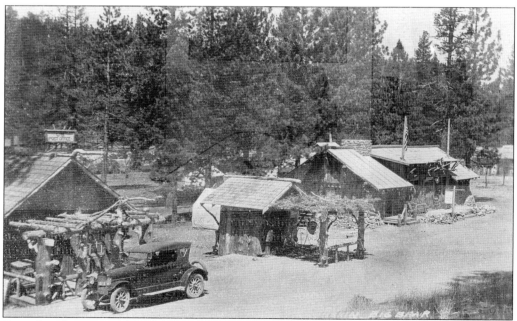

Fawnskin has existed since the trail up City Creek became a road that went through Hunsaker Flats (Running Springs) to Green Valley and Big Bear Lake, via the Snowslide Road, paralleling Grout Creek. Travelers were welcomed by a spectacular, panoramic view of the vast and beautiful lake.

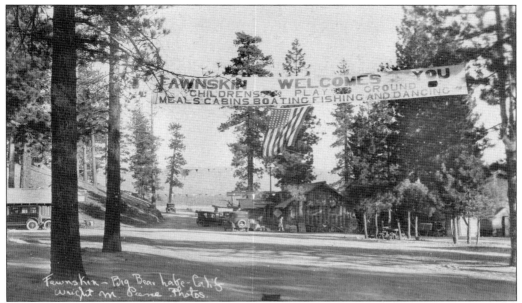

Not only a recreational area for adults, Fawnskin also has been a children's playground. This photograph postcard, dated September 15, 1924, reads, "Arrived up at this Lake Sun night. Sure had enjoyed the trip. The weather is Hundred in shade today. I expect it is some different weather out there [South Holland, Illinois] Wish you were here!"

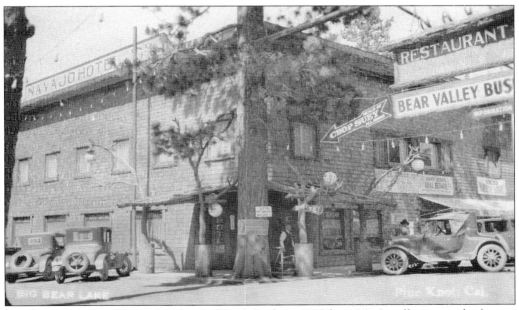

Lunch used to cost 65¢ at the Navajo Hotel. Built in 1920 by a Mr. Ingalls, it was the largest building in Big Bear for many years. It still exists but, in 1993, was remodeled and converted into a mall. Before that, it was a meeting place for many tourists, motion picture companies, and a real estate office for the Shay brothers. That 65¢ won't buy much there today.

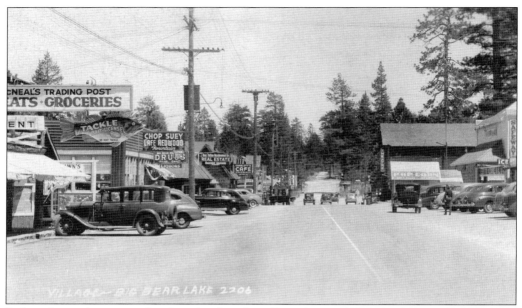

Before the road was completed to the dam from Fawnskin in 1924, travelers reached Big Bear Village from the east end. Many changes came quickly and, as historian Tom Core put it, "The decades-long transformation of the primitive and pastoral settlement of Pine Knot [developed] into the completely modern village of Big Bear Lake."

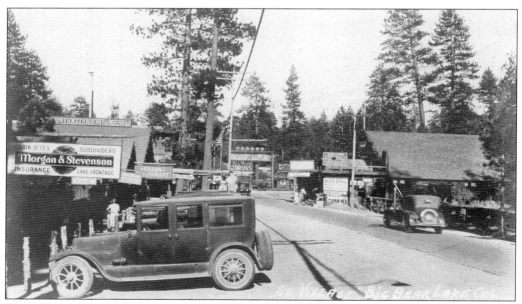

The village in the 1920s met most needs. The Navajo Hotel was equipped with showers, baths, music, dance, a soda fountain, and electric heat. If a visitor required more, a walk around town offered a drug store, Arion Putnam's gift shop, cabin sites to rent, and lakefront properties. If anyone wanted to build a cabin, Morgan and Stevens would sell off subdivided properties.

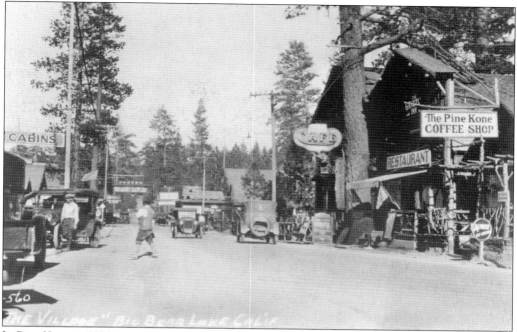

In Pine Knot in 1922, entertainment other than a dance meant dropping into the Grizzly Theater and Inn on Pine Knot Boulevard. The Grizzly Inn, located between the Pine Kone Coffee Shop and the theater, had a false front. The theater exterior was enhanced with manzanita and was an all-wood structure.

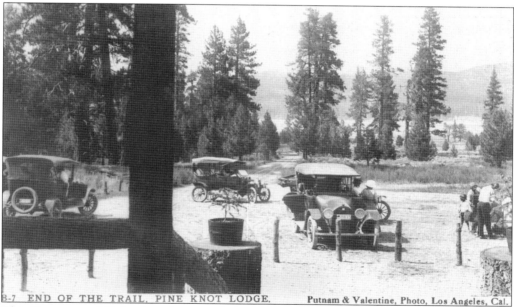

This Putnam and Valentine photograph (c. 1920) tells us that Pine Knot, as Big Bear was originally known, is the "End of the Trail." Those who made it up the steep inclines were greeted by a pristine view of Big Bear Valley and Big Bear Lake, but few facilities awaited them. When the weather was good, camping out under the stars was a pleasant alternative.

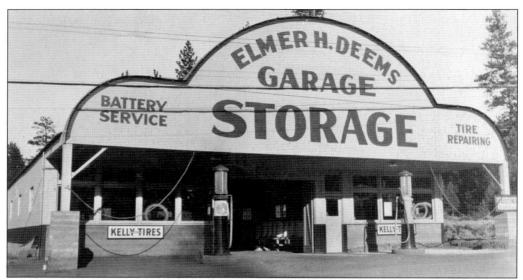

Elmer and Mabel Deems came to Big Bear in the 1920s as tourists and decided that this was where they wanted to live. They joined with Damon Cooley and opened a garage in 1921. Due to Elmer's accommodating attitude toward his customers, his business flourished, and he built this structure in 1926 on the east side of Pine Knot Boulevard. The Deems operated this garage until 1942, when they sold it and moved to San Bernardino.

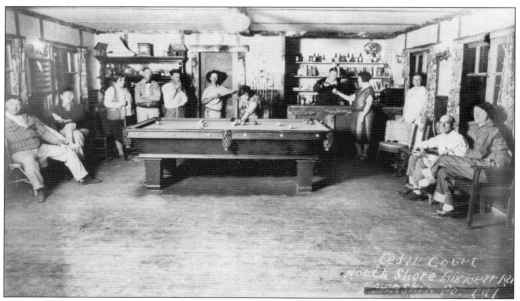

When Big Bear Village was alive with activity during the tourist season, so was the north side of the lake. Cedar Court sojourns cost $1 per person, even as late as 1939. Families could enjoy a spectacular view, modern plumbing, and even a boat landing. Fishing and swimming, of course, would have been on the schedule.

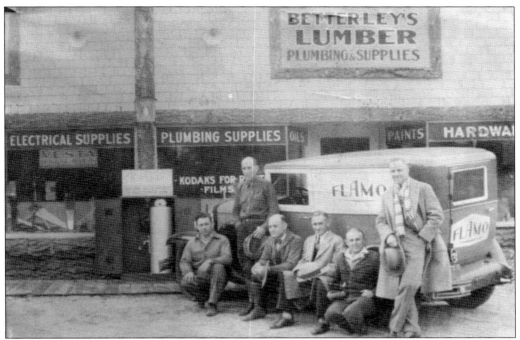

The Betterley family made its mark on the Big Bear area in many ways. Not only did they own and operate this hardware store, but Bill Betterley will always be remembered for one incident that old-timers cannot forget. Local firemen especially recall the day he drove one of their fire engines into the lake, not by his own poor judgment, but due to faulty brakes.

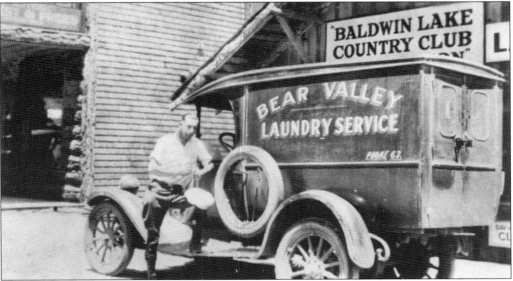

Rodney V. Wright was justice of the peace, master of the Masonic Lodge, assistant postmaster, graduate of the University of Southern California's class of 1923, businessman, and photographer. This man of many talents worked numerous jobs in Big Bear, including this one at the Bear Valley Laundry Service. He made many of the "penny postcards" that have become valuable to collectors today—some as much as $250.

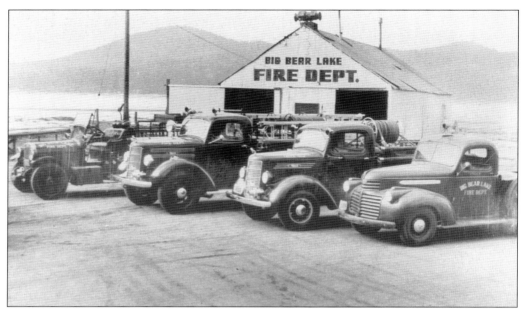

In 1927, the Big Bear Lake Volunteer Fire Department was formed, supported by community and local volunteers. Today there are four fire agencies: the Big Bear Lake Fire Department, the USFS, the California Department of Forestry, and the San Bernardino County Fire Department. All are kept busy, especially in October and November, when the notorious Santa Ana winds (or *Santanna*, as these "devil winds" were originally called by Native Americans) develop.

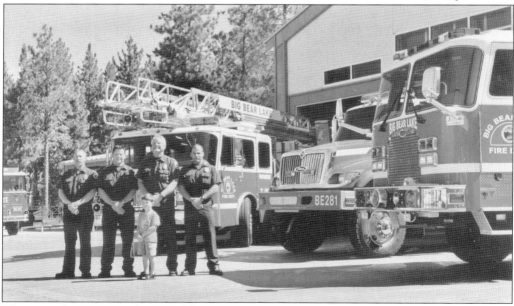

The recently constructed state-of-the-art Big Bear Fire Department facility provides the latest in equipment and care and is operated by full-time professional firefighters who are ready to respond to any emergency. Pictured here are firefighter David Jayne, fire engineer Ken Peterson, fire captain paramedic Rick Flint, firefighter paramedic Marcio Carvalho, and a visitor, young Alexander Nakamura.

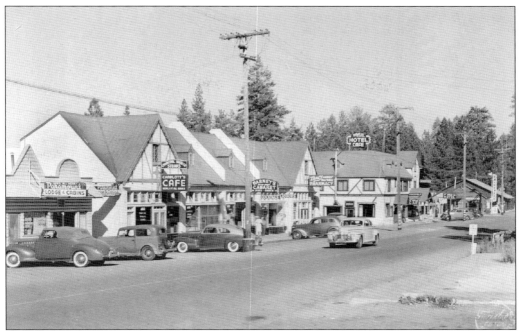

Village Drive was just as busy in the late 1930s as it is today. As soon as the mountains warmed up, tourists came to see the wonders of Big Bear. Plenty of shops and conveniences welcomed them. Beard's Department Store first opened in 1923 as the Village Trading Post. It had everything a sportsman needed, as well as Big Bear's first radio station, KMTR.

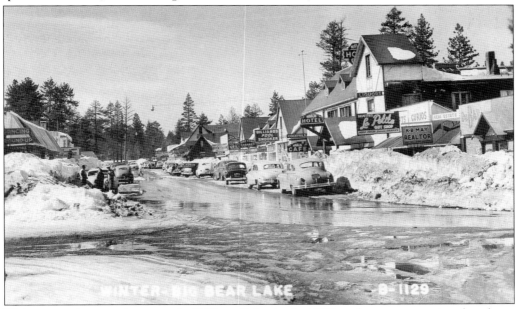

This snowy photograph postcard of Village Drive in the 1950s, taken on a warming day, shows the drive as it was between the early and later days of the village. Looking to the west are many of the businesses of the 1950s, with the Navajo Hotel on the right side. Many of these buildings were moved to other locations, destroyed by fire, remodeled, or replaced by more modern structures.

Village Drive is still an attraction to visitors of Big Bear Valley, even though this 2006 photograph (taken in the early morning on a weekday) may not give that impression. But on a weekend, with special events going on—such as the Corvette rally, the antique/performance car show with its usual 550 entrants, or the Old Miners' Day event—it is difficult to find parking near the attractions.

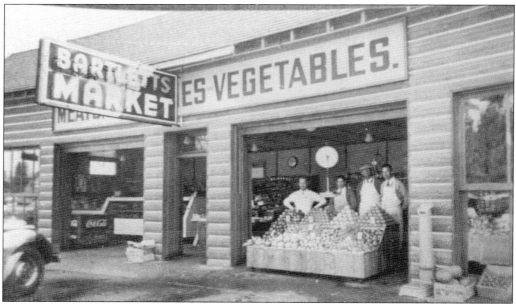

Soon after their marriage, X. G. and Rossie Bartlett came to visit the mountains in 1914. Like many other visitors, though, they decided to make the mountains home, and a year later, they leased commercial property with his brother G. M. Bartlett to build the first complete grocery and general store in the valley. The Bartlett family also added a gasoline station, café, and more cabins.

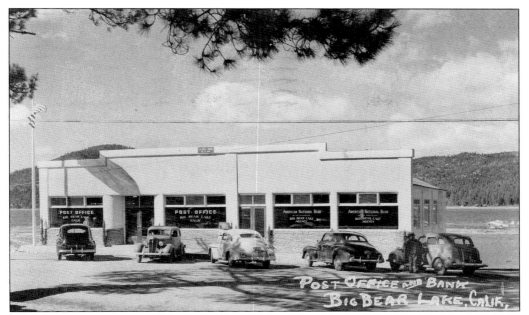

This photograph postcard of the post office and American National Bank is dated June 27, 1947, and is simply signed Laura, with no message. Originally known as the Van Duesen Post Office, a new name came about because patrons disliked the name and found it difficult to spell. Pine Lakes was the newly requested change, but the post office turned it down, favoring the present name.

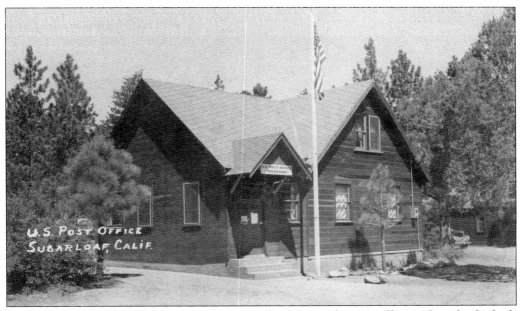

Several post offices have existed in Big Bear Valley. This is the post office in Sugarloaf, which came into existence on December 31, 1946, with Joseph H. Botkin as postmaster. It was located near the lower slope of Sugarloaf Mountain and was, at one time, located in Murphy's Market. It still operates as a "No Personnel Unit" with limited services.

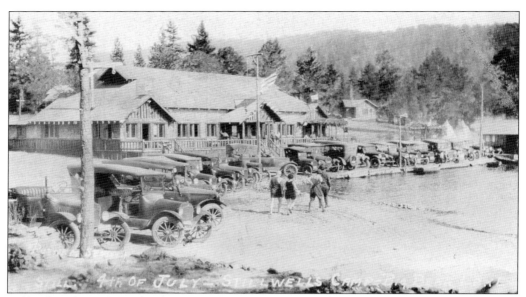

Stillwell's, a legendary resort, opened July 1, 1921, on a site selected by Carl and Mamie Stillwell and their son Charley. The success of this resort was evident from the beginning, with 500 people "at least" showing up for the opening, according to the *Big Bear Life*.

Fires destroyed Stillwell's—twice! In 1928, the ballroom was destroyed. It was rebuilt with a more modern structure on the same site. The second structure burned on December 8, 1945. New owners purchased what remained of the nightspot and later added a new dining house. Today it is very popular with locals and visitors and is known as the Blue Whale Lakeside Restaurant.

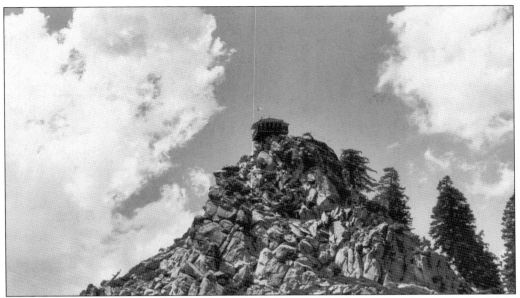

The USFS operates fire lookouts throughout the San Bernardino National Forest. Butler Peak, located on USFS Road 3N14, is one of the highest lookouts at 8,537 feet. It is manned by volunteers and cannot be reached during the heavy snow season. During the summer months, it is open to visitors, but four-wheel-drive vehicles are recommended to get there. Other lookouts in the San Bernardinos are Keller Peak, Morton Peak, and Strawberry Peak. (Courtesy Kenny Wood.)

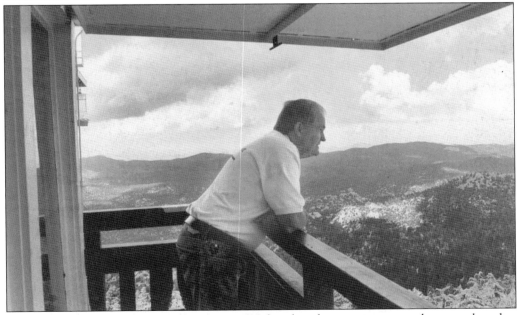

Volunteer Steve Cawsey may be lonely at 8,537 feet, but the view is spectacular on a clear day. From Butler Peak, one can see for miles in any direction: lakes, the Pacific Ocean, Catalina Island, deserts north and east, and fires small or large. Travelers along the "Arctic Circle" portion of Highway 18 can see this lookout by looking to the north along the top of the ridge. (Courtesy Kenny Wood.)

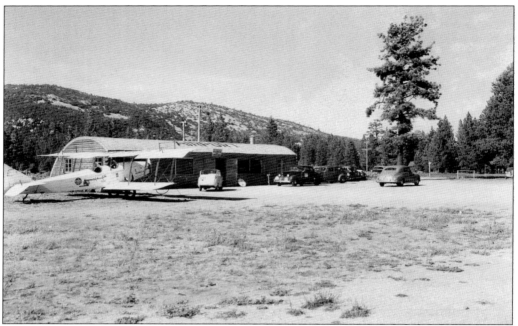

Waldo Waterman flew his French Thomas Morse Scout LaRhone, with a 110-horsepower rotary engine, into a field east of Big Bear Lake in 1916 and, unknown to him, opened up a new era for the valley. Not many years later, a landing field was graded and Waterman's feat was followed by many more pilots who proved this was a faster way to reach the valley.

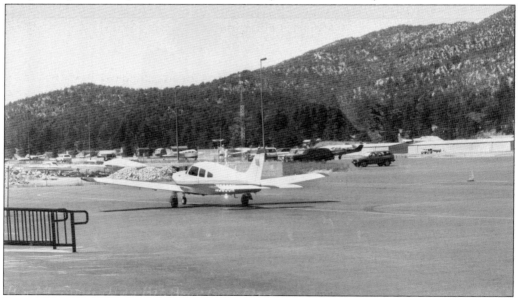

Pictured here in 2006, Big Bear airport is 6,750 feet above sea level with a 5,850-foot runway; it provides all the facilities required for year-round operations. There is snow-removal equipment used in attempts to keep the runway open even during the worst of storms. It is located near the village and its conveniences and has its own restaurant. It was built on the golf course of the Peter Pan Club, which burned in 1948.

Seven

RECREATIONAL ACTIVITIES

Today the activities that one can enjoy in Big Bear are virtually unlimited. It was not always that way. Years ago, Big Bear's tourism season was only during the summer. During the harsh winters, the valley's economy died, as most folks fled to warmer climates. In those days, fishing, boating, and swimming accounted for most of the summer activities. However, during the late 1920s and early 1930s, major changes took place. Highways into the mountains were improved, and dependable and comfortable automobiles were more affordable. An excellent airport was established, and a growing population in Southern California contributed to greater tourism. But the real change that resulted in a year-round playground was the development of ski resorts, requiring increased infrastructure. This resulted in supermarkets, hospitals, financial intuitions, variety stores, restaurants, places to stay (hotels, motels, and homes), and numerous other businesses that could now operate at a profit. As a result, Big Bear is now a full-time, year-round bustle of activity. Many of these recreational activities are reflected in the following images. Enjoy!

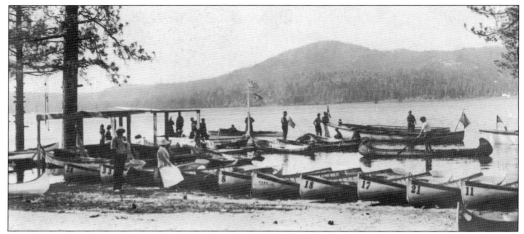

Boating and fishing were early activities on Big Bear Lake. In this view of Pine Knot Landing, c. 1910, several canoes are visible, although they are not a recommended craft for the sometime rough waters of Big Bear Lake. All of the small boats are powered with oars, but three larger motorboats are in the deeper water.

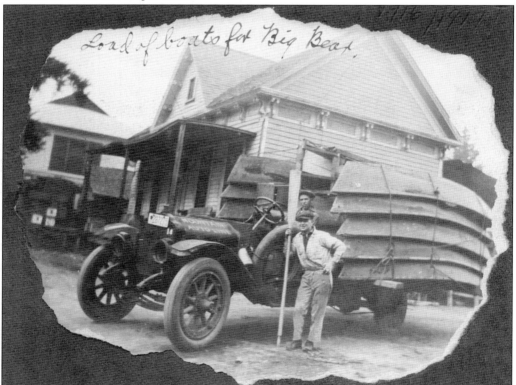

Boating on Big Bear Lake is a wonderful way to relax and enjoy the picturesque mountain vistas. In this original photograph, one of the Mountain Auto Line trucks is loaded with boats for delivery to Big Bear. By the time the automobile line was busily hauling passengers and supplies into Bear Valley, fishing was a major attraction. With 52 resorts in business around the lake in 1921, more boats were needed.

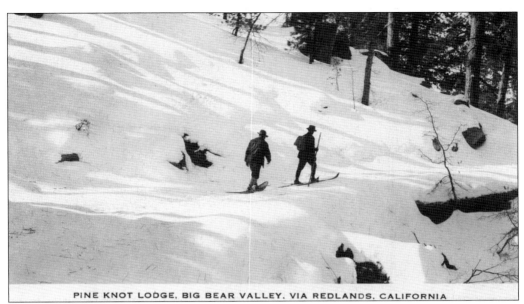

PINE KNOT LODGE, BIG BEAR VALLEY, VIA REDLANDS, CALIFORNIA

"Pine Knot Lodge—Big Bear Valley" is the caption on this early postcard. Although not confirmed, it is believed the lead man on this postcard was Fritz Fisher, who was the first confirmed user of skis in the valley in 1915. Fritz's father, Henry Fisher, was prominent in the development of the historic Pine Knot Lodge.

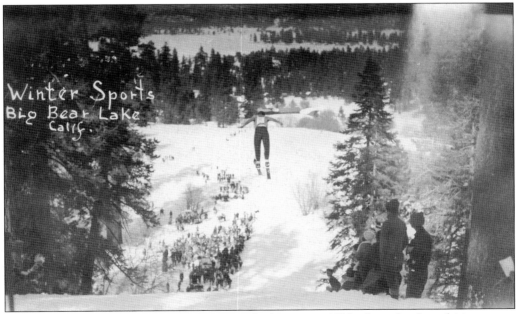

Winter sports at Big Bear received a major kick-start in 1928 when the first ski jump was built. Charley Stillwell built a snow slide at his resort, and a ski jump was located near the elementary school in Pine Knot. These attractions finally aroused interest in winter activities in Bear Valley.

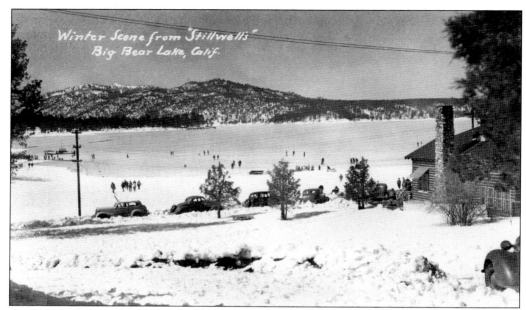

Winter Scene from "Stillwell's" Big Bear Lake, Calif.

Yes, it does snow in Big Bear Lake. This image depicts the second Stillwell's, which in the early days, was the center of valley social life. Numerous meetings, weddings, fund-raisers, and high-school graduations occurred there. The message on the back of this postcard states in part, "Hello everyone! We got here and everything is better than we thought. It is perfect!"

Mel Smith's Ballroom Orchestra Stillwell Camp – Big Bear Lake – Calif.

Stillwell's quickly became known throughout Southern California for its excellent dance floor, good music, romantic lighting, and magnificent setting in the forest on the shores of Big Bear Lake. The message on the back of this postcard reads in part, "This is a picture of the great music we have here. Some Jazzy."

Another winter recreational activity enjoyed some time ago was ice boating. This postcard, mailed in 1921, shows two gentlemen on their homemade ice boat. A frozen lake and a good wind could make for a mighty exhilarating ride.

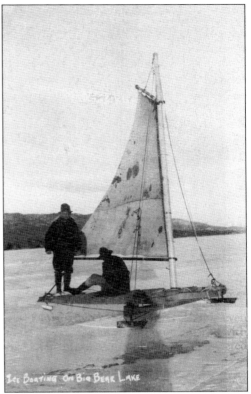

Ice Boating on Big Bear Lake

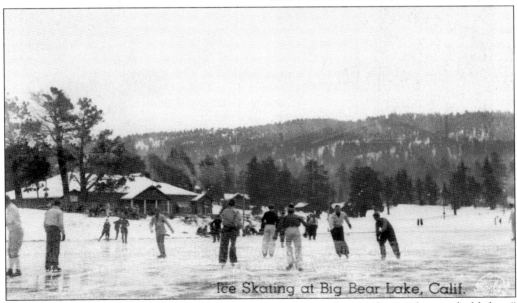

Ice Skating at Big Bear Lake, Calif.

Ice-skating on the frozen Big Bear Lake was enjoyed more frequently in "the good old days." In the late 1920s, the snowfall was heavy, and the lake was frozen solid each winter. Following a newspaper story about the thick ice on the lake, Sears Roebuck sold 700 pair of skates in one season.

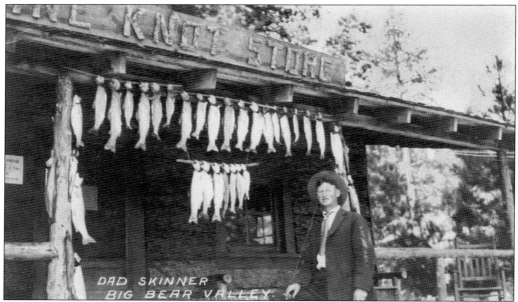

Fred C. "Dad" Skinner managed the Pine Knot Lodge between 1914 and 1928. His friendliness earned him the nickname "Dad," and his love and promotion of Bear Valley dubbed him the "One Man Chamber of Commerce." And, from the looks of this haul, he was a pretty good fisherman, too.

The caption on this postcard reads, "Largest Trout, 1941—14½ lbs. Big Bear Lake." The smile on this crusty old fisherman is worth a thousand words, as he stands with his catch in one hand and a cigar in the other. The sign on the window of the Bear Lake Chamber of Commerce reads "Big Bear Lake Police."

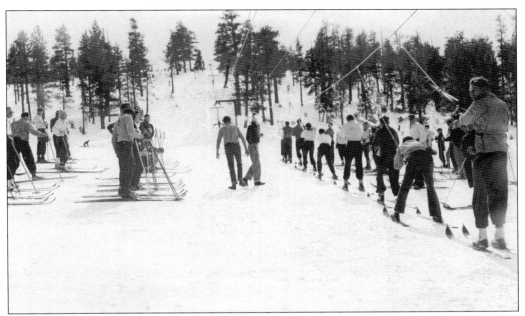

The Clifford R. Lynn drag-sling lift was the first to be built in Bear Valley, named after the man who had the vision and determination to bring the first ski lift of any kind to Bear Valley. This image, c. 1939, reveals that lift lines are not a new phenomenon.

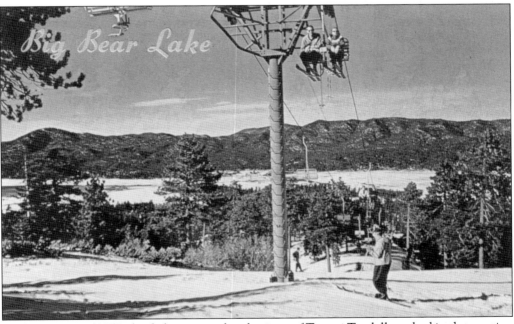

By the summer of 1952, the dedication and enthusiasm of Tommi Tyndall resulted in the creation of the Snow Summit Ski Corporation. Tommi, with a long and distinguished skiing background, created a mile-long, double-chair lift, which reached the top of the mountain. Here on the north slope, two major ski runs were installed, as well as several rope tows. This created the largest ski development in the San Bernardino Mountains.

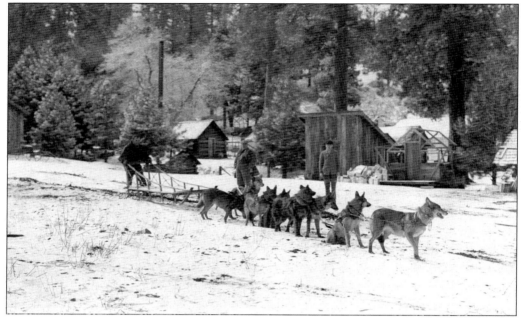

This is a very early image of a sled-dog team at Pine Knot. The heritage of the sled dog is a long and proud one, stretching back thousands of years. The people of the North were dependent on these animals for protection, companionship, hunting, trapping, and—most of all—transportation.

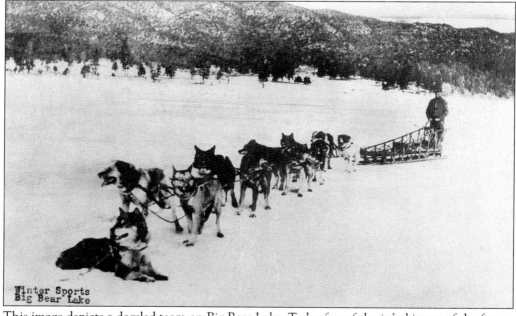

Winter Sports
Big Bear Lake

This image depicts a dogsled team on Big Bear Lake. Today few of the inhabitants of the frozen areas are dependent on dogs for basic transportation or survival. However, the same intimate relationship between driver and dog still exists and is demonstrated in this sport.

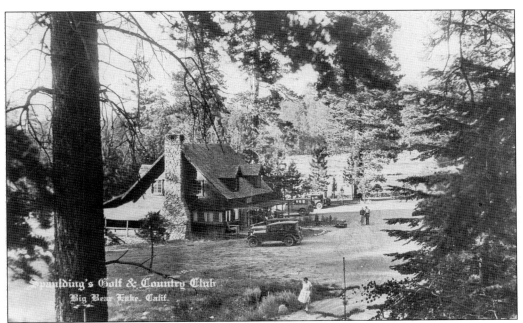

Pictured here is Spaulding's Golf and Country Club. The club was located in a nearby area called Moonridge, so named through an early subdivision-naming contest. The winner was awarded a lot in the subdivision. Today Moonridge is the site of hundreds of fine homes and condominiums, an excellent golf course, and a world-class ski resort.

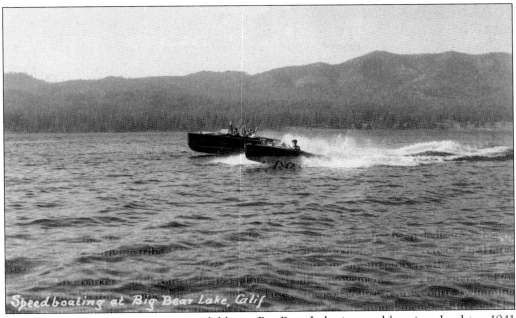

Another of the many activities available on Big Bear Lake is speed boating. In this c.1941 photograph, a couple of boats are engaged in a speed duel for the photographer. These wooden crafts are quite a sight today and always attract a crowd.

In this photograph, snow all but covers the Big Bear Bakery. Snowdrifts of this size were more common years ago, and some monumental snowfalls have been recorded over the years. In the gold rush days of Holcomb Valley, there was 16 feet of snow dumped on the ground in one day. The winters of 1937 and 1969 left mountain residents deep in the cold, white stuff. More recently, the porch can be kept clear with only a broom.

The winter of 1938 was one for the record books. Here a nearly buried cabin is visible in the foreground. To the left is the Motor Transit Depot. The mailer of this card has taken the liberty to draw a couple of sunbathers on the snow. The message on the reverse states in part, "how do you like Catherine's art, she does very good water colors?"

When looking for things to do, or just getting acquainted with a new area, there's no better place to start than the chamber of commerce. However, in this early 1950 photograph of the Big Bear Lake Chamber of Commerce office, getting in was difficult. The information center offers information on resorts, ski lifts, and instructions.

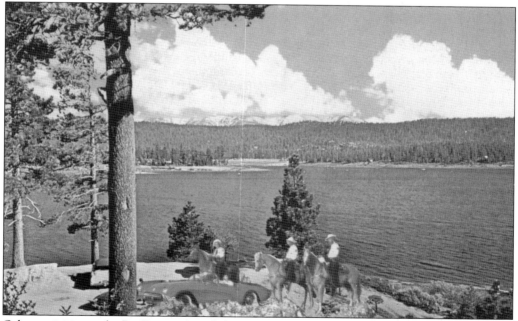

Other activities in the Big Bear area include "convertibling" or horseback riding. What better way of "convertibling" can there be than riding around the lake in a 1957 Corvette? Or, for a slower pace, riding on horseback is a wonderful way to enjoy the spectacular views.

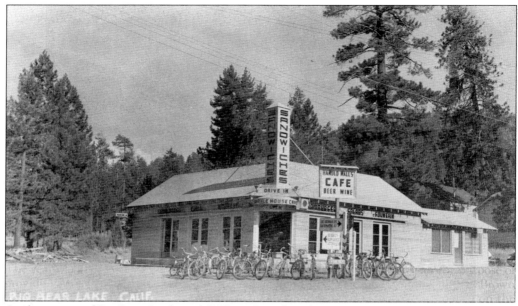

At the corner of Big Bear Boulevard (Village Drive) and Pine Knot Drive was once the site of Harold Walls Café. The café featured beer, wine, sandwiches, salads, hamburgers, chili, waffles, and a fountain. Another activity enjoyed in the Big Bear area is renting bicycles. Today bicycling is very popular in Bear Valley, and mountain biking in the backcountry has become not only a recreational pastime but also a competitive sport.

Castle Rock is prominent on the skyline above the south shore of Big Bear Lake. A well-marked trail leads to the great monolith. The trail starts at Highway 18, about one mile east of the dam. Sightseers are perched precariously at the top left in this photograph. Other publications on Big Bear tell the story of the Native American "Legend of Castle Rock," in which a young girl named Wyhnemah realizes that her lover Pahwak is not returning. She steps off Castle Rock with a prayer on her lips to join him in the Happy Hunting Ground . . . forever.

The Big Bear Solar Observatory (BBSO) located in Big Bear Lake is operated by the New Jersey Institute of Technology. Since it is completely surrounded by water, distortion caused by terrestrial convection is reduced. The original dome, built in 1969, is currently being replaced by a new and bigger one that will house a new 1.6-meter solar telescope. This will be the world's largest solar telescope and is scheduled to be operational in late 2006. Because it observes the sun, it is only in use during the day.

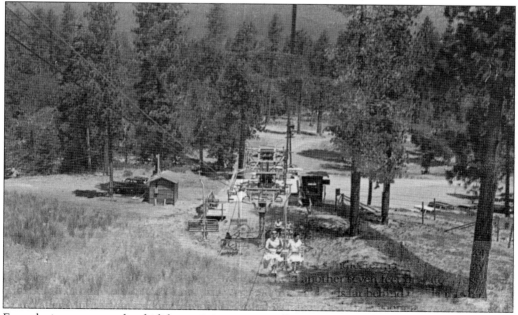

Even during summer, the ski lifts are in operation, offering guests a relaxing ride and panoramic views of Bear Valley. These ladies enjoy the two-mile, round-trip ride at Snow Summit.

One of the many things to do in Big Bear is nothing. This young lady is relaxing above the lake and enjoying the view. Treasure Island, with its Chinese–style home, is visible at the left. Other observers or sunbathers are visible on the rocks below.

Celebrated annually in Big Bear Lake is Old Miner's Week. Several parades are staged throughout the year and include old cars, floats, bands, and horseback riding.

Eight

MOVIES

The movie industry wasted no time in discovering potential in the San Bernardino Mountains, since they are located so close to Hollywood. It was only a matter of time until the attraction of tall timbers, grassy meadows, and crystal-clear lakes drew the attention of filmmakers. By early 1911, they were filming in the lower parts of the San Bernardino Mountains above Redlands and at Arrowhead Springs. The upper ranges provided an attractive shooting location, with hunting and fishing lodges readily available to house the film crews. By mid-1911, the Bison Company had arrived in Redlands on the way to Big Bear Valley to set up a studio.

Movie producers have maintained a love affair with the San Bernardino Mountains, which has resulted in hundreds of movies being filmed here. Over 150 films have been made wholly or in part in Bear Valley. Perhaps the most influential movie ever made in the San Bernardino Maintains was *The Birth of a Nation*, filmed in 1914. Subsequent classics filmed in Bear Valley include *Gone With the Wind* and *The Last of the Mohicans*. It is estimated that more than half of the movies filmed in the San Bernardinos were filmed in Bear Valley and Cedar Lake. Film historian Lee Cozad has intensely researched this subject. (See Bibliography.)

The Call of the North, a 1914 Cecil B. DeMille film, was filmed at Big Bear Lake. Here Cecil B. DeMille (in puttees behind the camera) and Alvin Wyckoff watch Winfred Kingston and Robert Edeson go through a scene with the lake in the background. This film, DeMille's second, established him as a director of compelling influence for many years to come. (Courtesy Lee Cozad.)

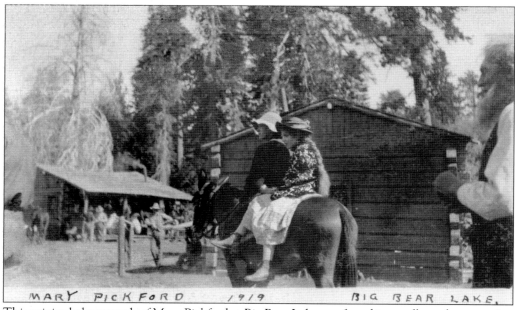

This original photograph of Mary Pickford at Big Bear Lake was found in an album documenting the Townsend family's vacation to Big Bear in August 1919. Pickford was born in 1892 in Toronto, Canada, and died in 1979 at the age of 87. She was film's first international superstar, and she occupies a unique position as the first lady of film and America's sweetheart.

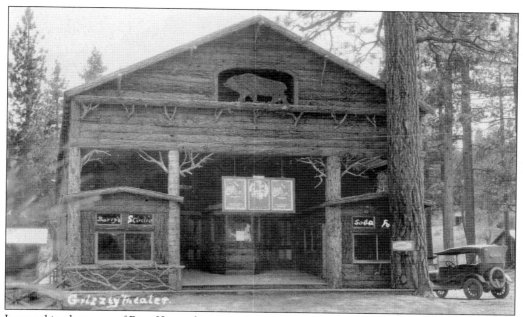

Located in the town of Pine Knot, the rustic Grizzly Theater stood with a ferocious wooden bear high above its entrance. The theater was built in 1920 by Frank Johnson for $20,000. When it first opened, it had no seats and everyone brought their own crates or packing boxes to sit on. In June 1941, the popular Grizzly Theater was destroyed by fire.

The Birth of a Nation, filmed in the summer of 1914, has been called racist, brilliant, inaccurate, and inflammatory. The legendary D. W. Griffith masterpiece was far ahead of its time in cinematography and content and has a running time of three hours. The heroine jumps to her death off the cliffs above Big Bear Lake. These same cliffs were chosen for Tourneau's *Last of the Mohicans* five years later. (Courtesy Lee Cozad.)

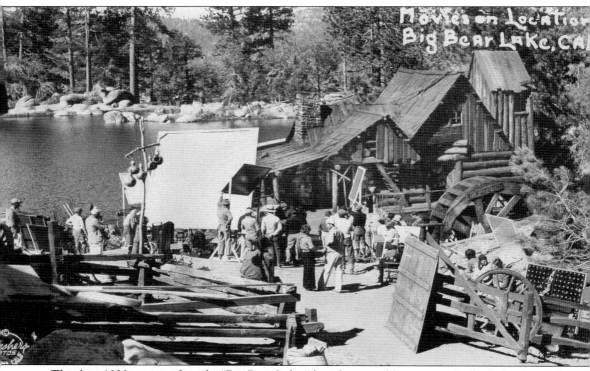

This late 1930s postcard reads, "Big Bear Lake," but the actual location is Cedar Lake, located approximately a half-mile south. The Talmadge brothers bought the land in the 1890s to graze cattle, selling in 1922 to the Bartlett brothers. Feeling that a lake on the property would help them sell lots, they had a 30-foot dam constructed in 1929, forming the three-and-a-half acre Cedar Lake. In 1937, Guy Bartlett bought the land with plans to develop a resort. When that didn't pan out, he promoted Cedar Lake as a tourist attraction and charged an admission fee. Part of the lure for tourists was the use of Cedar Lake by the movie industry, which began filming there in the mid-1930s. Major studios have produced films here through the years, including *Trail of the Lonesome Pine* (1936) with Henry Fonda, *The Parent Trap* with Hayley Mills, and *Kissin' Cousins* with Elvis Presley. Television shows like *Bonanza*, *Lassie*, *FBI Story*, and *Hart to Hart* were also filmed here. By the 1950s, Bartlett had increasing difficulty making a profit. The First Congregational Church of Los Angeles entered the picture after visiting several Lake Arrowhead properties, searching for a camp to help increase their youth membership. The church purchased the Cedar Lake property in January 1955. Improvements include the building of the 300-capacity amphitheatre in 1984 and a chapel in 1991 with the same design and location as the old mill used in *Trail of the Lonesome Pine*.

Producer David O. Selznick, who had a home in Running Springs, chose the Big Bear Lake area for scenes of *Gone With the Wind* (1939) because he felt the locale best represented the tall pines of Georgia. During one scene, after the defeat of the South and the era of Reconstruction, Scarlett (Vivien Leigh) must drive by a dangerous area referred to as Shanty Town. As she drives her horse and buggy over a small bridge, she is accosted by two men asking for a handout. Big Sam (Everett Brown), her father's ex-foreman, comes to her rescue.

King of the Mounties (1942) was a 12-episode serial from Republic Pictures, which finds Canada being bombed mercilessly by a mysterious enemy plane. This poses a threat to the Axis chiefs in preparing western Canada for an invasion. The stars include Allan Lane, Gilbert Emery, and Russell Hicks. It was filmed at Big Bear Lake and Cedar Lake. (Courtesy Lee Cozad.)

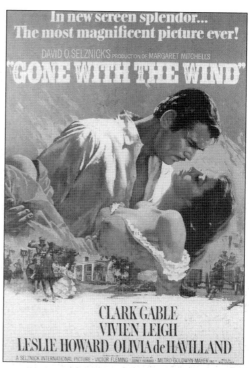

119

The original version of *The Parent Trap* (1961) starring Hayley Mills was filmed at Big Bear Lake, Bluff Lake, Cedar Lake, and Lake Arrowhead. Mills plays twins who, unknown to their divorced parents, meet at a summer camp. Products of single parent households, they switch places (surprise!) so they can meet the parent they never knew, and then contrive to reunite them. Portions of the 1998 remake were shot in nearby Crestline, California. (Courtesy Lee Cozad.)

Kissin' Cousins (1964) starring Elvis Presley was filmed at Cedar Lake. It follows the exploits of a military man (Elvis) trying to convince his hillbilly cousin (Elvis) to allow a missile site to be built on his land. Yes, Elvis plays a dual role in this one and is visible in the doorway.

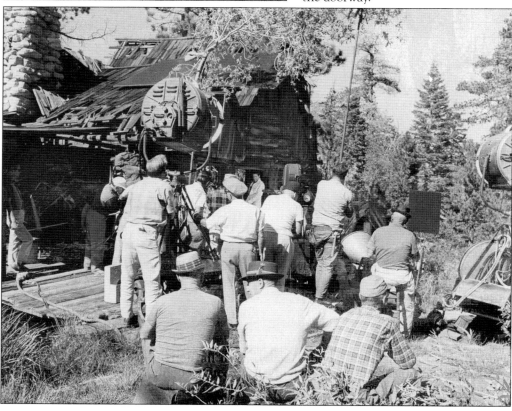

Nine

BIG BEAR TODAY

A first-time visitor to the Big Bear Valley surely could not find enough time to do everything he or she would like during one stay. There are shops galore for the souvenir hunter, a museum to visit, as well as a wildlife center, interpretive center, boat rides, stables, golfing, skiing, riding and hiking trails, backcountry tours, remnant locations from the gold mining days, and on and on.

If the newly arrived tourist does not return to visit again and again, at least he or she will probably never forget their stay in Big Bear. A visitor once remarked that, as a professional tennis player, his career had taken him to all major cities around the world, and yet he had never seen a place as beautiful as this mountain community.

Many of the people who come are descendants of parents and grandparents who brought them here. They in turn have come to remember their former visits and enjoy the environment with their own families, who, in all probability, will return with their own families someday.

Occasionally nothing seems more refreshing than a day at Big Bear to revive the soul. Whether this time is quietly spent sitting on the lake shore with a fishing pole or walking or biking around the lake trail to enjoy deep breaths of pine-scented mountain air, one may just have to return to "recharge the batteries."

Each year, 550 entrants drive in the annual antique car show, bringing hundreds of visitors to see the vintage automobiles. Displayed in this very popular event are some automobiles in better stock condition than they were when they left the show room—some remanufactured and some just plain "tricked out."

The Renaissance Faire is held each year in Big Bear. This annual event, a touch of old England, has become more popular each year, with music from the great European era, participants in costume, food, arts and crafts, clothing, and displays.

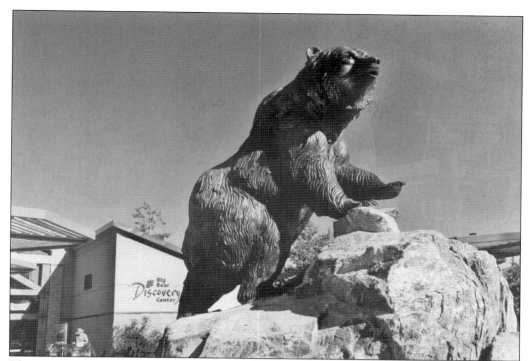

The Discovery Center is located on the north shore of Big Bear Lake, west of the USFS ranger station and the Stanfield Cutoff and north of the USFS campground. This modern facility is at the head of several hiking trails and bike paths that are popular with visitors to the Big Bear area.

The North Shore Hiking/Biking Path is a busy place in the summer, and it presents an easy grade for joggers, walkers, bikers, baby strollers, and wheelchairs. It begins just west of the North Shore School, goes less than a mile to the USFS campground, under the highway, and ends—or begins, if you prefer—at the Discovery Center.

Visitors can take a ride on a pirate ship around Big Bear Lake for an unforgettable experience. Unlike its real counterpart, this one is driven by internal combustion engines. Unlike the food served up to the notorious pirate Black Sam, food is prepared in a style accustomed to the wishes of those who choose to take this adventure.

The Big Bear Historical Society operates at the museum on the eastern end of the airport. The museum is open during the summer months and run by volunteers. Here Jim Lanners demonstrates the art of preparing a meal from a chuck wagon. A remnant stamp mill can be seen at the museum, as well as an operating blacksmith's shop.

On a visit to the Moonridge Animal Park, one can see some very rare animals, including these bald eagles. In the wild, they come to Big Bear to escape the winters of Montana, Wyoming, and Canada. Erv Nichols from the Discovery Center conducts eagle tours each year. He explains that these creatures can see 10 times better than humans and dive at speeds of 100 miles an hour to claim prey.

As soon as families came to the Big Bear area, children needed to be educated. The first high-school senior class consisted of 15 students. The class met on the second floor of Heller's Department Store. Today's high-school graduates number 200 from an upper-grades enrollment of nearly 1,000. A total of more than 3,000 students are enrolled in seven schools throughout Big Bear.

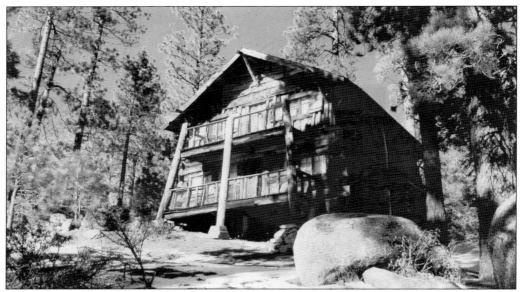

Originally built in 1910, this was possibly the sixth home built in Fawnskin. Prior to film director William Wellman Sr.—*The Public Enemy* (1931), *A Star Is Born* (1937), *Beau Geste* (1939), and *The Story of GI Joe* (1945)—purchasing the home in 1941, it was owned by actor Lew Ayers. Believing his wife, Ginger Rogers, wanted a divorce, Ayers purchased the home and proceeded to make renovations with the dream of presenting it to Ginger as a symbol of his love. She never saw the home, and they divorced in 1940. Lew sold the home to Wellman, and it remains in that family today.

On November 22, 2005, Tom Core Day was held to celebrate Big Bear's historian. On that day, the road leading to the Big Bear Museum was named Tom Core Drive. A song, entitled "Bellville Symphony," was written for the occasion by Lou Hatfield, and speeches were given by Bob Colven, director of the Big Bear City Community Services District, and Gloria Meade, president of the Big Bear Valley Historical Society. Tom and his wife, Ruth, were joined by a large crowd of well wishers. The rock pillar that supports the street sign was originally constructed by Tom when he was 15 years old. It originally stood across the road and marked the entrance to the prestigious Peter Pan Club.

Selected Bibliography

Beattie, George, and Helen Beattie. *Heritage of the Valley*. Oakland, CA: Biobooks, 1951.

Big Bear Valley Historical Society. *Guide to Historical Big Bear Valley*. Big Bear City, CA: Big Bear Valley Historical Society, 1988

Core, Tom. *Big Bear, The First 100 Years*. Big Bear City, CA: Tom Core Trust, 2002.

———. *Ghost Town Schoolmarm*. Big Bear City, CA: Tom Core Trust, 1993.

Cozad, W. Lee. *Those Magnificent Mountain Movies*. Lake Arrowhead, CA: A Rim of the World Historical Society Publication, 2002.

Elliott, Wallace W. *History of San Bernardino and San Diego Counties*. Riverside, CA: Riverside Museum Associates (Reproduction of 1883 original), 1965.

Garrett, Lewis. "Postal History of San Bernardino County." *San Bernardino County Museum Quarterly*, Redlands, CA, Vol. 39, No. 4, Fall 1992.

Ingersoll, Luther A. *Century Annals of San Bernardino County, 1769–1904*, Los Angeles, CA: L.A. Ingersoll, 1904.

LaFuze, Pauliena. *Saga of the San Bernardinos*. San Bernardino, CA: San Bernardino County Museum, (2 Vols.), 1971.

Lyman, Leo, *San Bernardino*. Salt Lake City, UT: Signature Books, 1996.

Pedder, Beatrice. "Big Bear Panorama," Big Bear High School, Big Bear City, CA, 1934.

Robinson, John W. *The San Bernardinos*. Arcadia, CA: Santa Anita Historical Society, 1989.

Trimble, William J. *The Mining Advance into the Inland Empire*. Madison: University of Wisconsin Press, 1908.

Videos

California's Gold. Huell Howser, Show No. 5011.

The History of Big Bear Lake, 1850–1970. Don Productions, 1999.

The Big Bear History Show, Channel 6, Big Bear City.

Websites

http://www.bbso.njit.edu/

http://us.imdb.com

http://www.webheads.co.uk/sdcom/press/info/003history.html.

ACROSS AMERICA, PEOPLE ARE DISCOVERING SOMETHING WONDERFUL. *THEIR HERITAGE.*

Arcadia Publishing is the leading local history publisher in the United States. With more than 3,000 titles in print and hundreds of new titles released every year, Arcadia has extensive specialized experience chronicling the history of communities and celebrating America's hidden stories, bringing to life the people, places, and events from the past. To discover the history of other communities across the nation, please visit:

www.arcadiapublishing.com

Customized search tools allow you to find regional history books about the town where you grew up, the cities where your friends and family live, the town where your parents met, or even that retirement spot you've been dreaming about.